IMAGES of America
AROUND GLEN ROCK

On the cover: The First National Bank of Glen Rock building was two years old when this picture was taken in 1914. This building stands on the site of the previous First National Bank that was constructed in 1876 and razed in 1912. (Courtesy John Hufnagel.)

IMAGES
of America

AROUND
GLEN ROCK

Bob Ketenheim

ARCADIA
PUBLISHING

Copyright © 2009 by Bob Ketenheim
ISBN 978-0-7385-6462-3

Published by Arcadia Publishing
Charleston SC, Chicago IL, Portsmouth NH, San Francisco CA

Printed in the United States of America

Library of Congress Catalog Control Number: 2008939173

For all general information contact Arcadia Publishing at:
Telephone 843-853-2070
Fax 843-853-0044
E-mail sales@arcadiapublishing.com
For customer service and orders:
Toll-Free 1-888-313-2665

Visit us on the Internet at www.arcadiapublishing.com

*To the people of Glen Rock,
who will celebrate their 150th anniversary in 2010.*

Contents

Acknowledgments 6

Introduction 7

1. Business and Industry 9

2. Churches and Schools 41

3. Life around Town 55

4. Life in the Surrounding Area 93

Acknowledgments

A project of this magnitude is never the work of just one person. In this case, dozens of people came forth and unselfishly shared their photographs, their documents, and their memories.

I express my deepest gratitude to Phil Attig, Miriam Bradfield, David Carpin, Anna Dubbs, Dale Dubbs, Earl Dubbs, Sandy Fair, Steven C. Grove, John Hufnagel, Ed Hughes, Frank Ingham, Arlene O. Keller, Bob Keller, Joy Keller, Barb Krebs, Daniel Jesse Mays, Kerry and Deb McKnight, Nellie Moser, Gina Mumaw, Roger Shaffer, John and Jane Shriver, Calvin Sotdorus, John and Fran Spring, and Sally Zimmerer.

I extend a very special thank-you to John Hufnagel, who proofread the text and ensured that the facts about Glen Rock are correct. Known as the local expert on the town, John has a wealth of knowledge about Glen Rock.

I wish to thank my wife Patti for being patient and understanding, especially during the stressful times.

Last but not least, I thank Erin Vosgien, my editor at Arcadia Publishing. She has patiently guided me through three publications with Arcadia. No matter what the circumstance may be, she has always been positive, cheerful, enthusiastic, and supportive when dealing with me.

INTRODUCTION

The intent of this book is not to tell the history of Glen Rock and its surrounding area but to show how things and places looked at certain times in the past. For those interested in learning more about the history of Glen Rock, information can be found at the Arthur Hufnagel Public Library. There are books on the history of the town, sports in Glen Rock, and the Glen Rock Carolers.

Glen Rock is a small, residential town situated in a valley in south-central York County. It is located about 16 miles south of the city of York and four miles northwest of Shrewsbury.

Glen Rock was first settled by William Heathcote in the late 1830s. Heathcote selected the site to establish a felting mill because it was located along the right-of-way of the newly constructed North Central Railroad. The town's location also attracted a large sewing industry, just like the neighboring communities of Shrewsbury and New Freedom. A large lumber industry thrived in Glen Rock in the 19th and early 20th centuries. Coach works, furniture manufacturers, tin and iron works, a stove manufacturer, a steam bakery, and general merchandisers were all big employers during Glen Rock's boom. Just on the outskirts of the borough was the Foust Distillery, a maker of fine rye whiskey. Founded in 1858, the distillery operated until it was forced to close by Prohibition. The business was so popular in its day that a small community sprang up around the distillery complex that was known as Foustown.

The Glen Rock Carolers are popular in Glen Rock. Every Christmas Eve, members of the Glen Rock Carolers walk the streets dressed in traditional 19th-century garb serenading the town with Christmas carols. The carolers have been in existence since 1848 and their annual trek through the streets of the borough attracts hundreds of followers. The event begins in the middle of town at precisely midnight on Christmas Eve and continues until near daybreak Christmas morning.

Just outside Glen Rock is the main campus of the Southern School District of York County. Located on former farmland, the campus houses Southern Elementary School, Southern Middle School, and Susquehannock High School. The area served by the district has a population of about 20,000.

In June 1972, Tropical Storm Agnes destroyed or heavily damaged the rail line that connected Baltimore, Glen Rock, York, and Harrisburg. Most of the damage in Pennsylvania was repaired; however, that was not the case on the portion of the line in Maryland, and thus the mainline service of the Penn Central Railroad through the area ended. As a result, many of the businesses in the Glen Rock area that depended on rail service suffered. Today one set of tracks still exist along the line, but adjacent to them now is the Heritage Rail Trail that travels from the

Maryland–Pennsylvania line through Glen Rock to York. The trail draws thousands of walkers, runners, and bikers every year into Glen Rock, helping the town's local business.

Today Glen Rock is a quiet residential community in southern York County. Because of the area's easy access to Interstate 83, many Glen Rock–area residents can enjoy the peaceful surroundings at home and still travel approximately 50 miles to work in Baltimore, Maryland, or around 80 miles to the Washington, D.C., area.

One
BUSINESS AND INDUSTRY

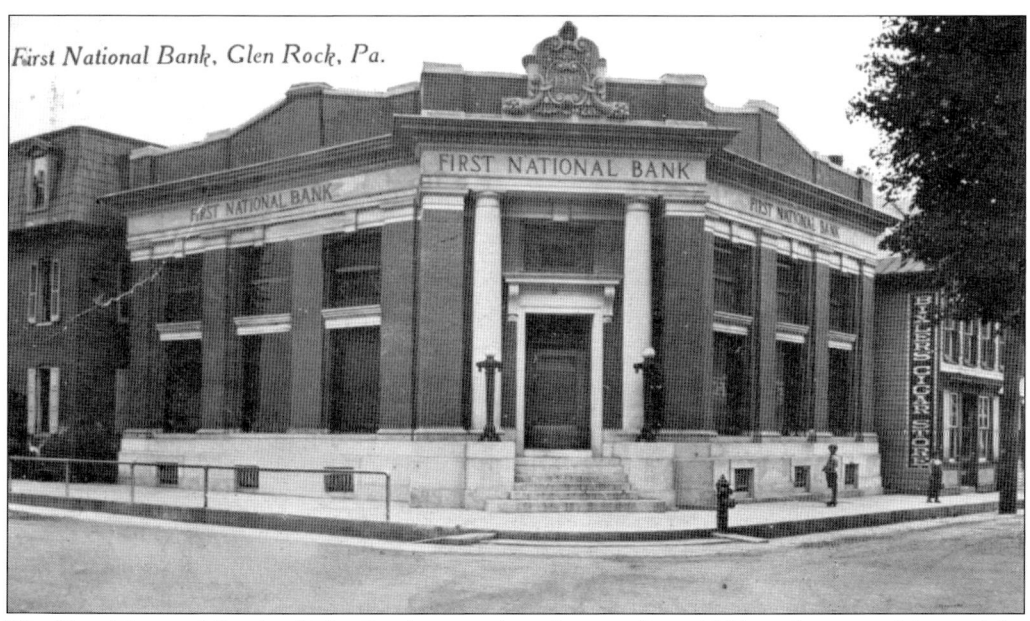

The First National Bank of Glen Rock opened its doors in June 1864 on the second floor of the Emanuel Sheffer building on Main Street. By 1876, the bank needed more space, so it moved into a new three-story building that had been erected on this site by Nathaniel Z. Seitz. In 1912, the old three-story building was razed and this building was erected. Today it is home to Peoples Bank. (Courtesy Steven C. Grove.)

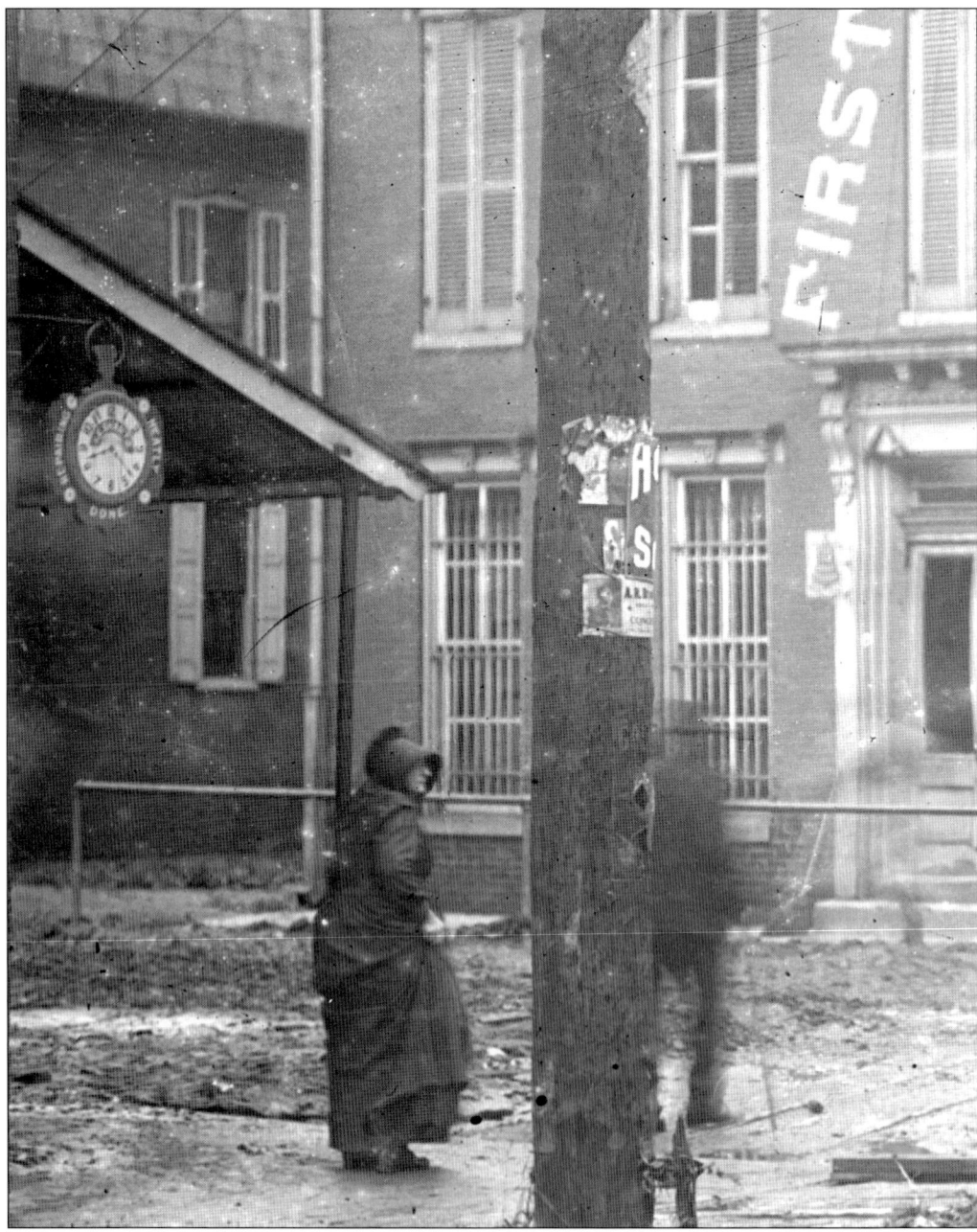

This 1911 photograph shows a portion of the facade of the Nathaniel Z. Seitz building a year before it was razed. The words "First Natl Bank" were written diagonally on the face of the building on Manchester Street and its right side on Hanover Street. Note the clock reads 8:23 a.m. (Courtesy Keller-Brown Insurance Services.)

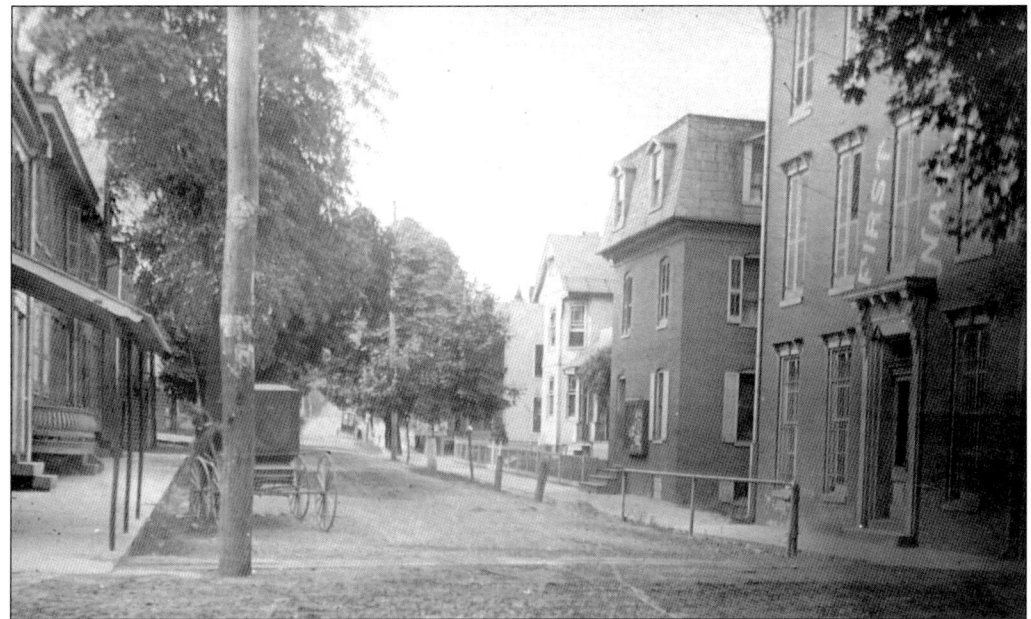

This early view of Manchester Street is from a postcard postmarked in 1909. The photographer is standing in the middle of the intersection of Manchester Street, Baltimore Street, Main Street, and Hanover Street. The building on the right just beyond the bank once housed the Glen Rock telephone exchange. It was later razed to make room for an addition onto the present-day Peoples Bank. (Courtesy Steven C. Grove.)

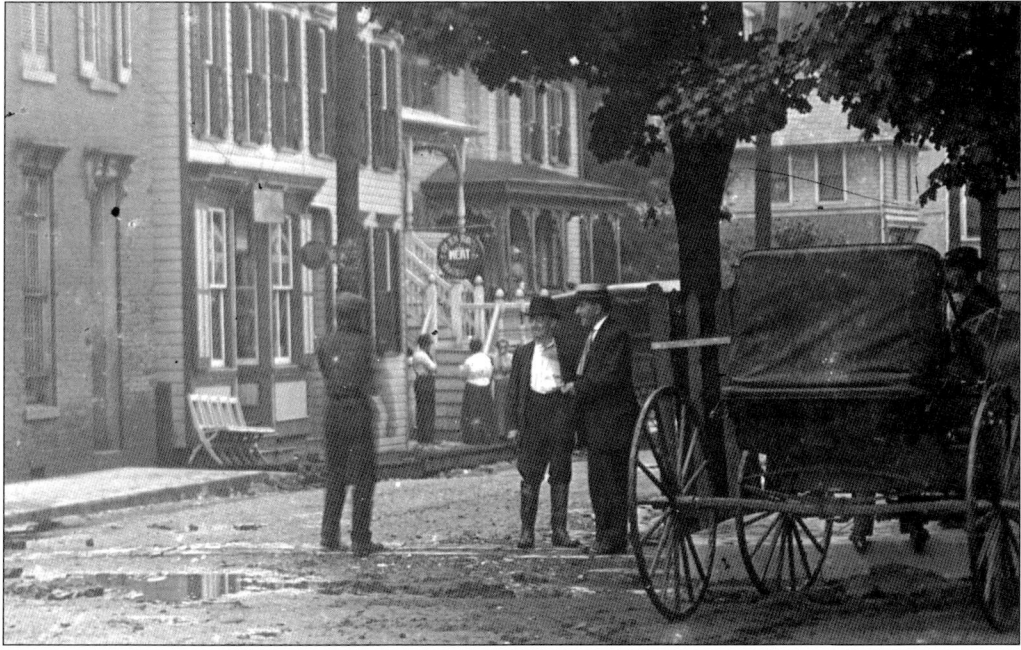

This 1911 photograph is looking down Hanover Street just beyond the First National Bank. The storefront beside the bank belonged to W. O. Bixler. The sign hanging in front of the next store reads, "Glen Rock Market." The Fountain Hotel is barely visible on the right in front of the buggy. (Courtesy Keller-Brown Insurance Services.)

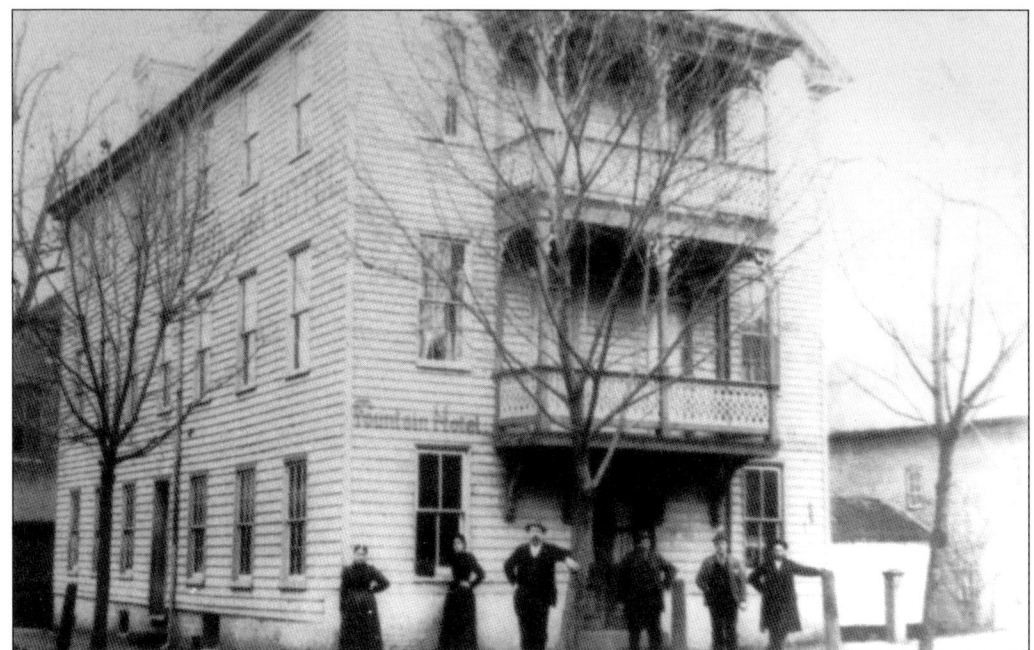

In 1867, Jonathan Faust built the Fountain Hotel on the corner of Main Street and Hanover Street. Faust operated the hotel until 1876 and retained ownership of the building until 1893. Additions were made to the building in the 1890s. It was a popular vacation place for people coming north from Baltimore by train. (Courtesy Steven C. Grove.)

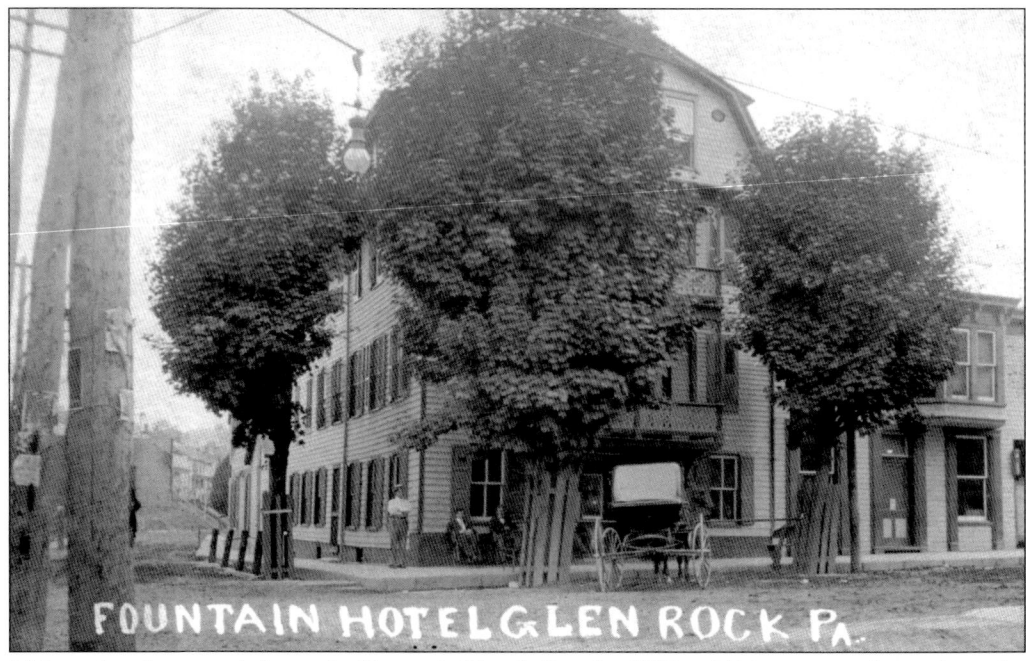

This undated postcard shows the Fountain Hotel after the 1890s addition was made on the right side. Note that in those days, the sidewalks do not extend out past the trees and the utility poles. Today with automobiles traveling at higher speeds, signs, fire hydrants, trees, and utility poles are protected from traffic by the extension of the sidewalks. (Courtesy Arlene O. Keller.)

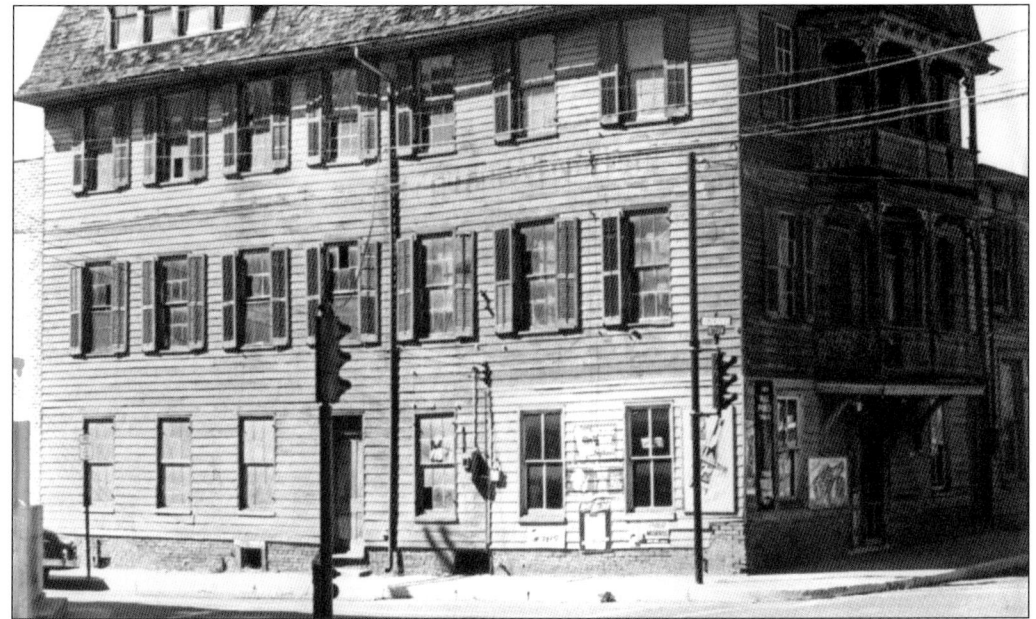

The Fountain Hotel was one of two popular Glen Rock hotels in the late 1800s and early 1900s. The popularity of the automobile and the decline in the use of passenger trains led to the eventual downfall of Glen Rock's hotels. Shown here in 1956 just before it was razed, the once-proud Fountain Hotel had fallen into a state of disrepair. The words "Fountain Hotel" are still barely visible between the second- and third-story windows. (Courtesy Steven C. Grove.)

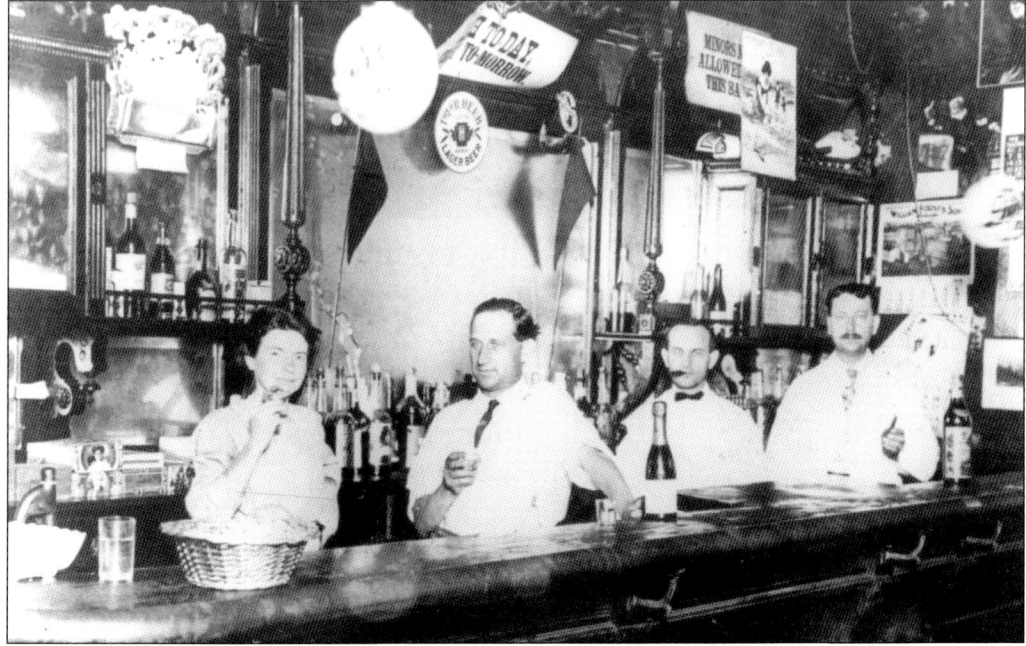

This is a January 1912 photograph inside the Fountain Hotel. From left to right are Grace Rohrbaugh Abel, Benjamin Franklin Abel, Cooney Seitz, and Hen Young. Benjamin and Grace operated the hotel at the time, and they were the parents of Arlene (Abel) Keller, who was born in the hotel in 1913. (Courtesy Steven C. Grove.)

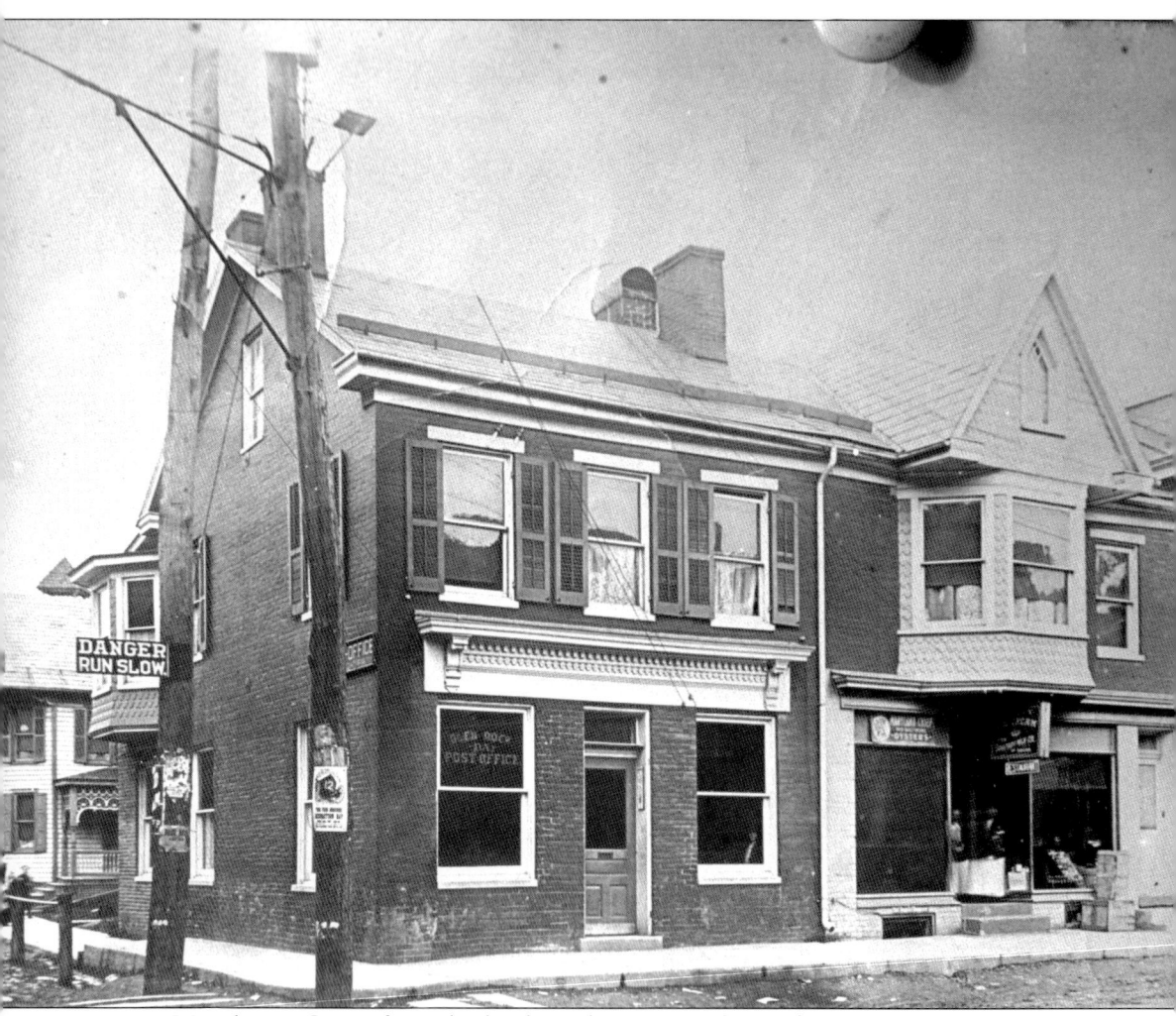

Across Manchester Street from the bank at the corner of Manchester Street and Baltimore Street was once the location of the Glen Rock Post Office. Next door to the post office is a restaurant. The sign atop the left window of the restaurant advertises Maryland Chief Oysters. Note that in this undated picture, the utility poles are in the street away from the sidewalk. (Courtesy Keller-Brown Insurance Services.)

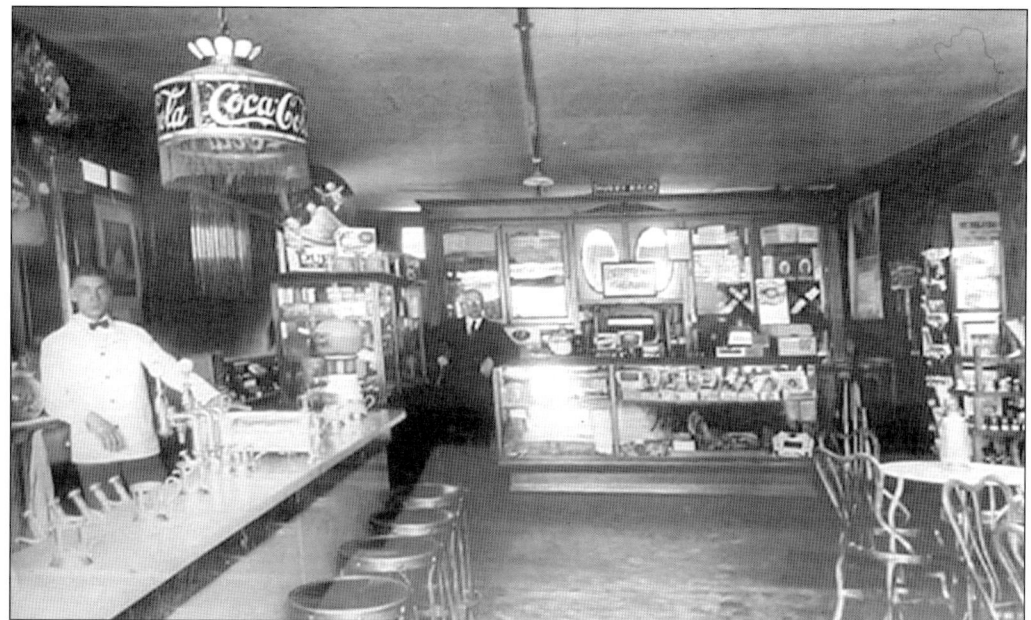

In 1898, W. O. "Pop" Bixler opened a cigar store at 4 Hanover Street, just behind the First National Bank. Bixler became the sponsor and the manager of the town's baseball team and, later, the town's basketball team. His store became the unofficial headquarters of such sporting activities in Glen Rock. This early-1900s photograph shows the inside of the store with a soda fountain. (Courtesy Bob and Fran Keller.)

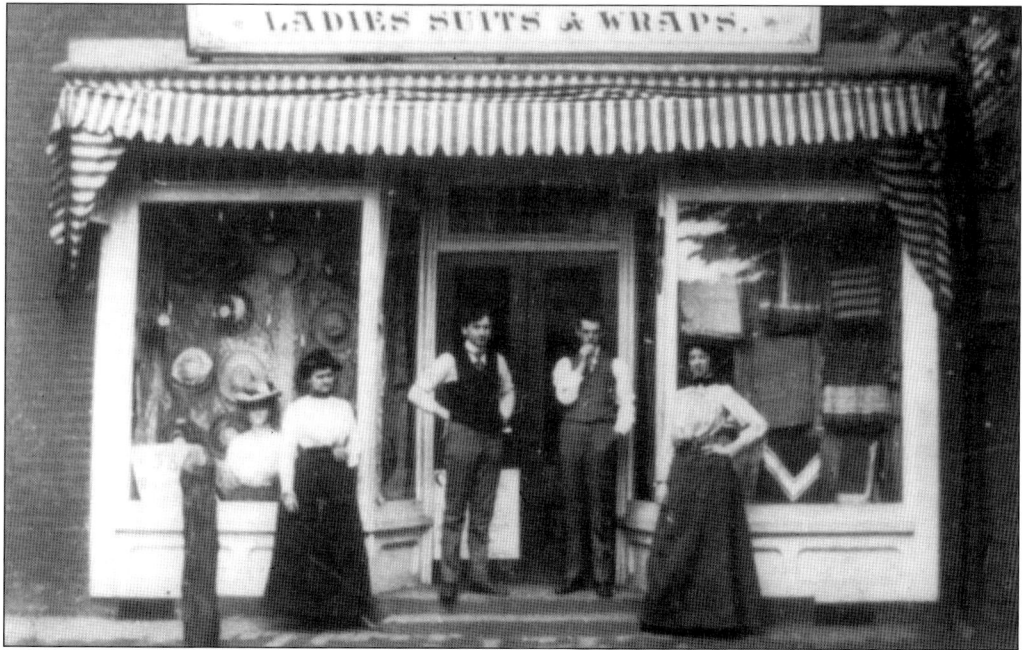

This 1890s photograph shows the Glen Bargain Store at the corner of Hanover Street and Water Street. Decades earlier, this building was used as a school. It was later torn down to make room for Theodore Cramer's general merchandise store. The location of the Glen Bargain Store was across Water Street from the Zion Lutheran Church. (Courtesy Steven C. Grove.)

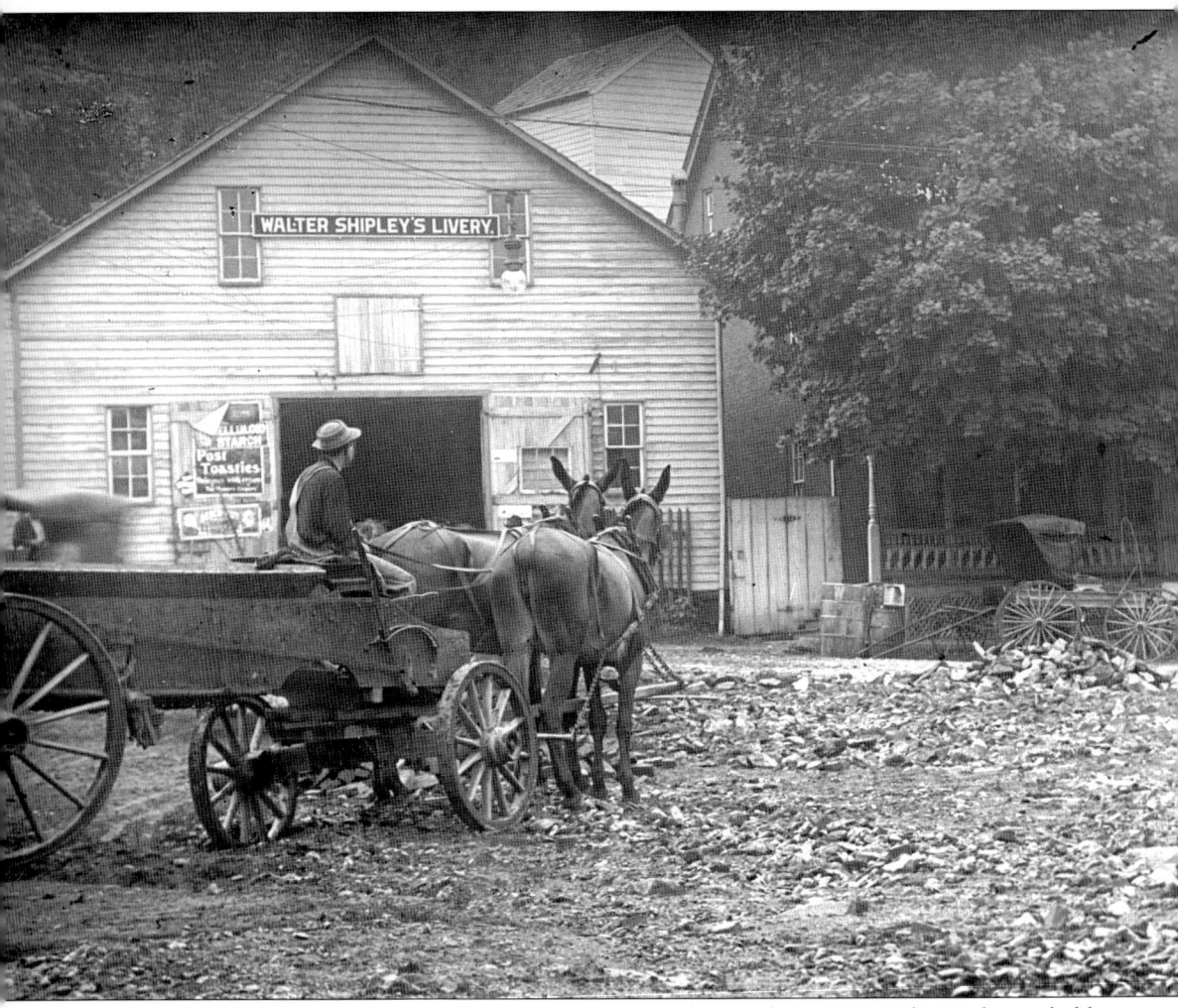

People riding into town on horseback or by buggy and intending to stay the night probably needed livery services. The same was true for someone who came to town by rail and needed to rent a horse and carriage. It was located on the corner of Church Street and Main Street, now the location of Glen Rock State Bank. Note the Post Toasties advertisement to the left of the doors. (Courtesy Keller-Brown Insurance Services.)

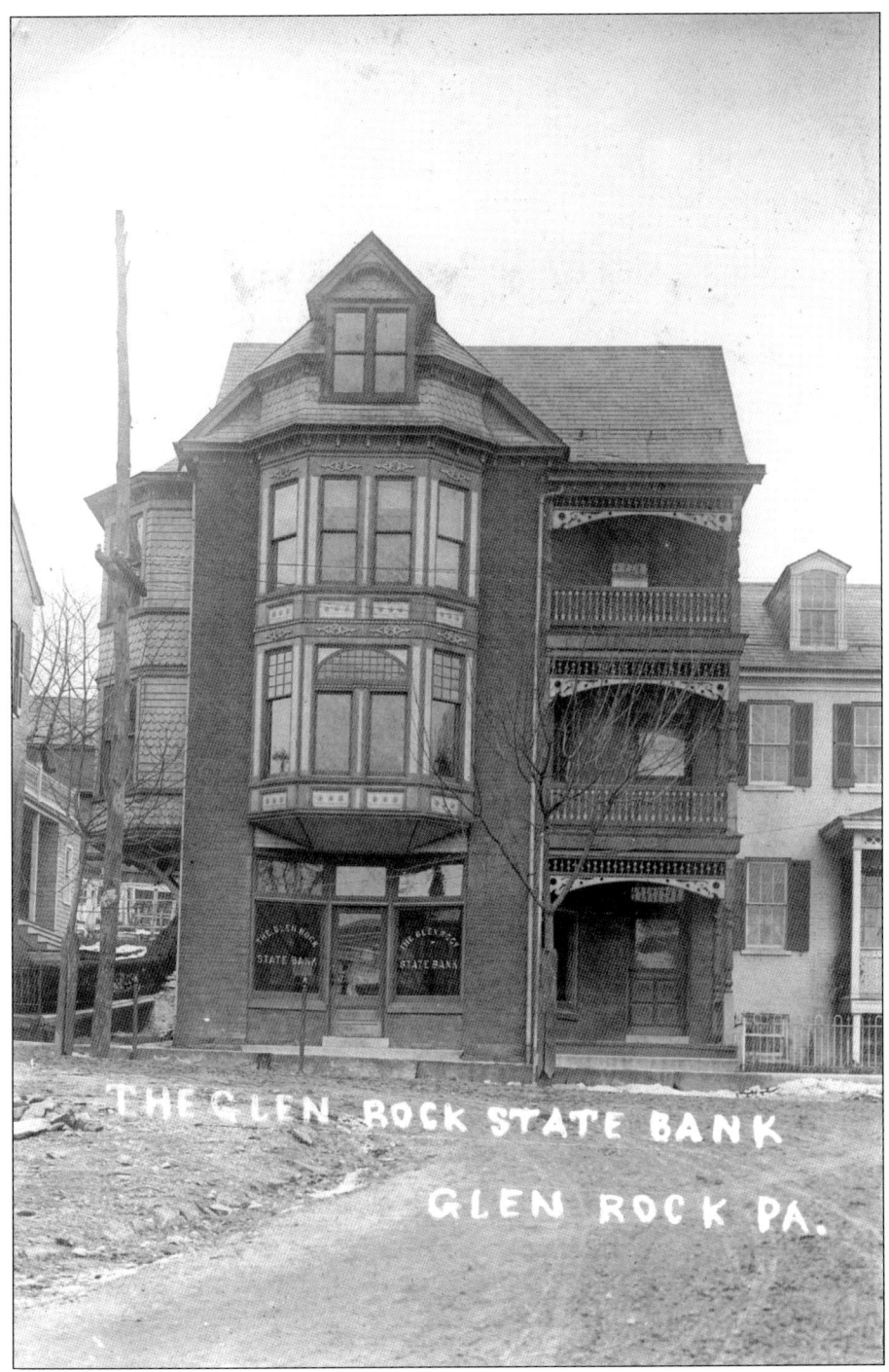

This is a photograph of 45 Main Street after the Glen Rock State Bank moved to the location on August 28, 1910. The building housed the bank and two apartments. Before the bank moved in, there was a poolroom on the first floor. The building was razed in the early 1950s to make room for Geiple Funeral Home. The bank was at this location only about a year before it moved to 111 (now 115) Main Street. (Courtesy Steven C. Grove.)

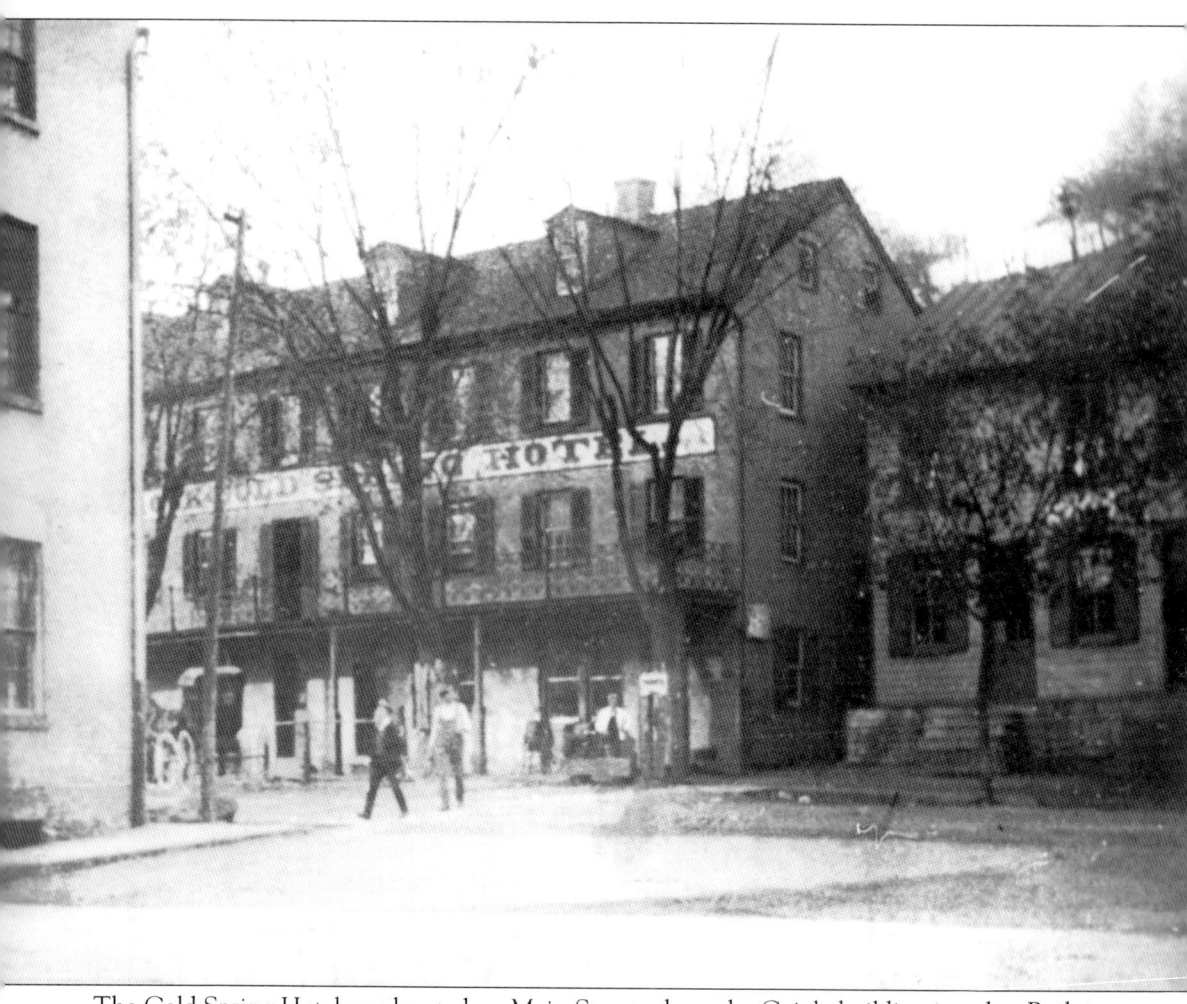

The Cold Spring Hotel was located on Main Street where the Geiple building is today. Built in the mid-1800s, the 30-room hotel got its name from the cold water that ran from the spring in its courtyard. The hotel stood conveniently across the street from the Emanuel Sheffer building, which was also the railroad station. (Courtesy Keller-Brown Insurance Services.)

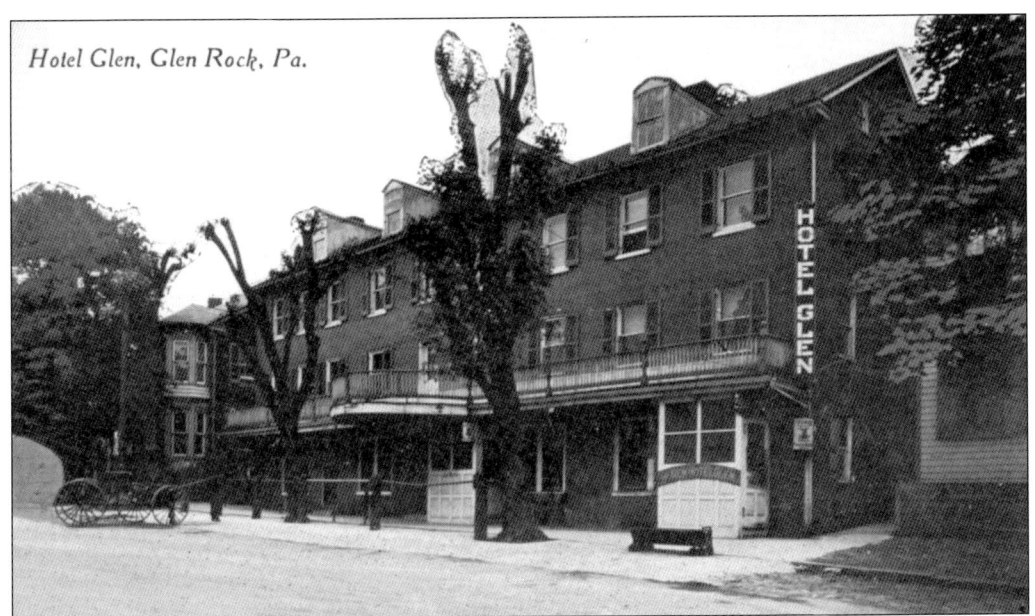

After 1900, the hotel became the Hotel Glen. It was still a conveniently located 30-room hotel and, by this time, it offered its guests rooms with electricity. This picture shows that the front was remodeled to provide a circular balcony. The hotel business ended at this location in the 1920s. (Courtesy Steven C. Grove.)

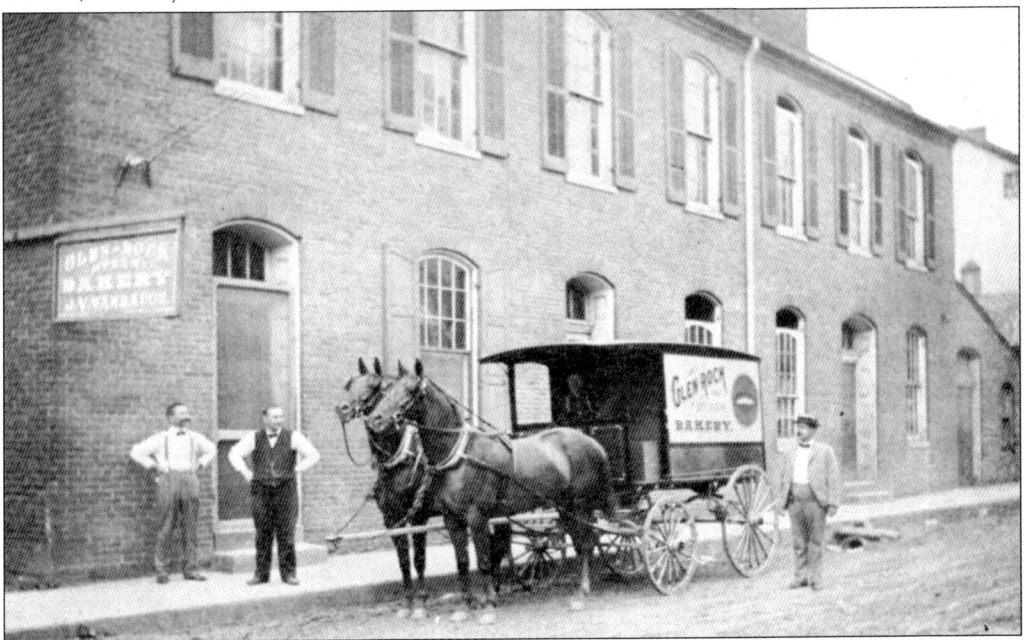

The Steam Bakery was built by the Heathcote Company in 1880 as a woolen mill to manufacture felt blankets. Not long after, a shoe factory was opened there by Granville F. Heathcote. In 1902, William Lau began a bakery here, and Victor Wambaugh and I. R. Knapp also operated bakeries from this location; the last closed on March 14, 1970. The attic was used for town meetings, social events, and to show silent movies. The site became a parking lot when the building was razed in the early 1970s. (Courtesy Steven C. Grove.)

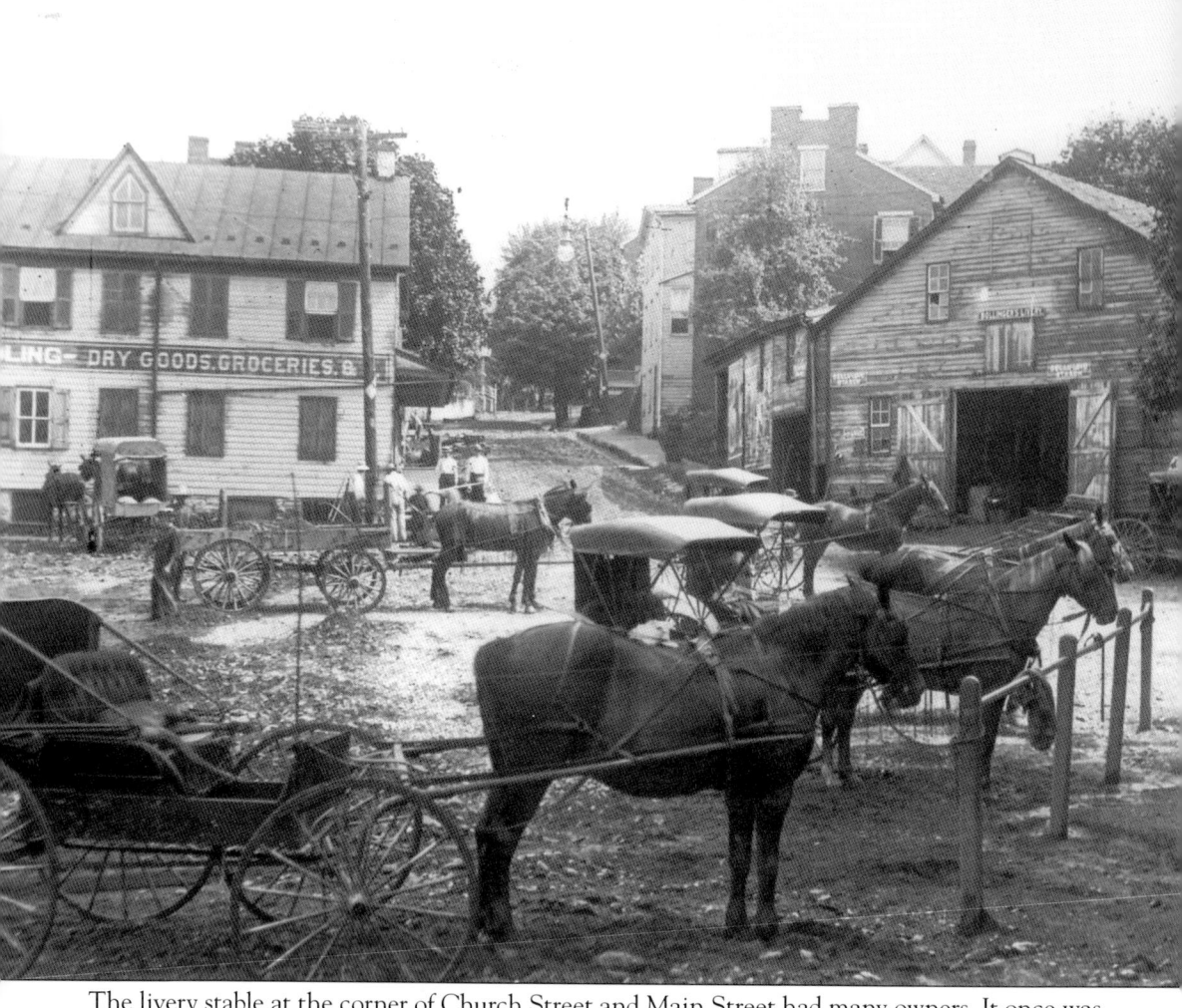

The livery stable at the corner of Church Street and Main Street had many owners. It once was operated by the Cold Spring Hotel, Edward T. Eyster, George Bollinger, and Walter Shipley. This livery stable was one of four located in town. (Courtesy Steven C. Grove.)

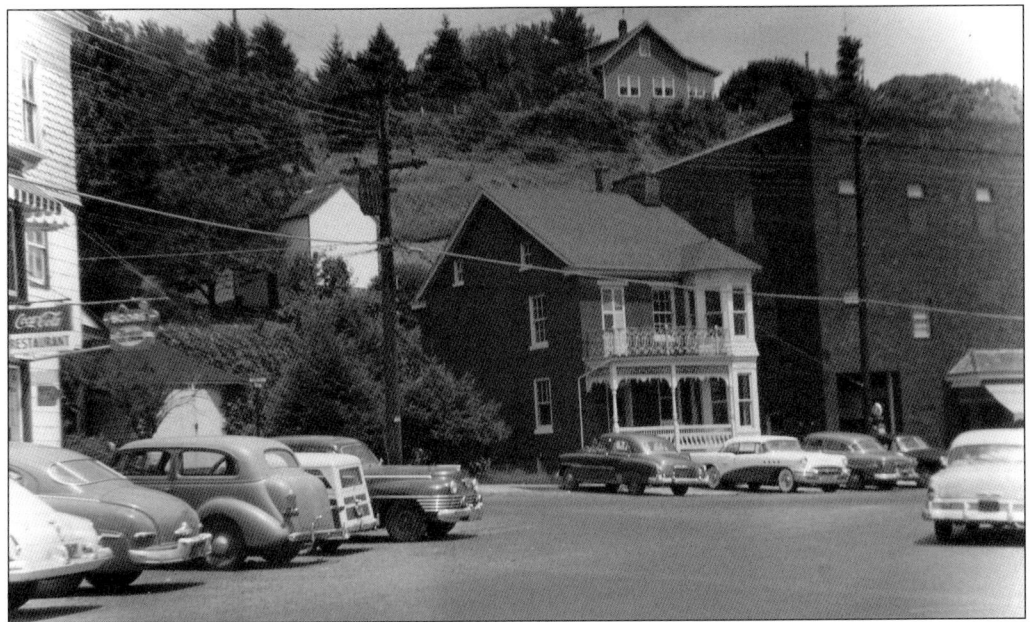

This 1950s photograph shows the intersection of Church Street and Main Street. The livery stable is long gone, and it has been replaced by the Bertrum D. Allison residence. The house stood on this site until 1956, when it was razed and replaced by the Glen Rock State Bank. (Courtesy Keller-Brown Insurance Services.)

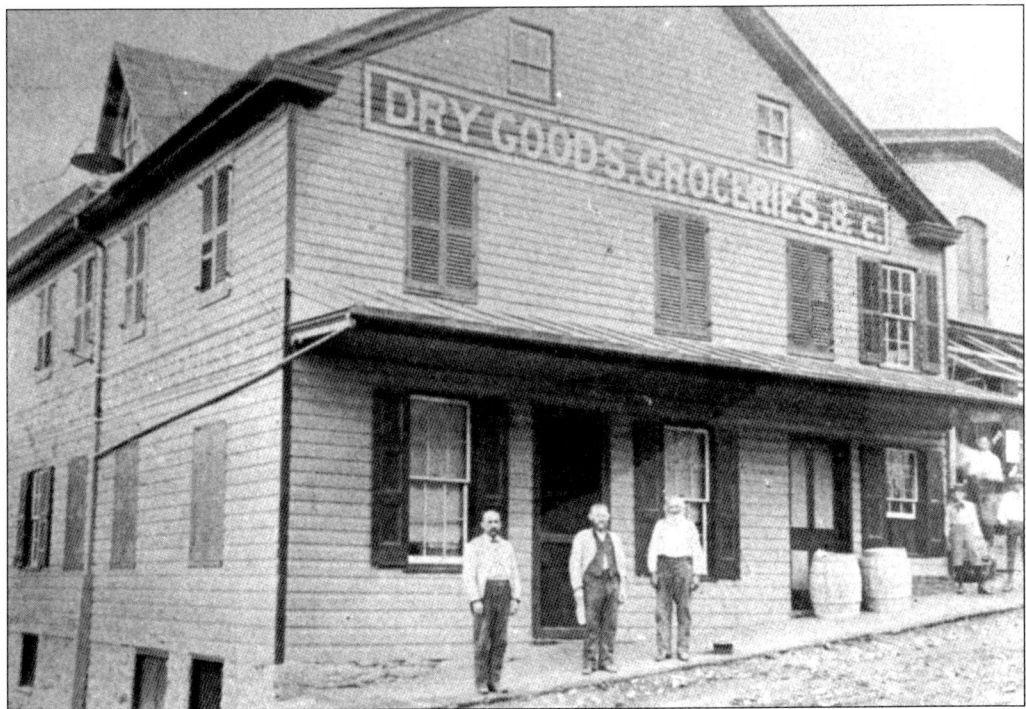

Across Church Street from the livery stable on the opposite corner was a large wood-frame building that was built in 1866–1867. For about 70 years, it was used as a dry goods store operated by numerous owners. In later years, it housed several restaurants. (Courtesy Steven C. Grove.)

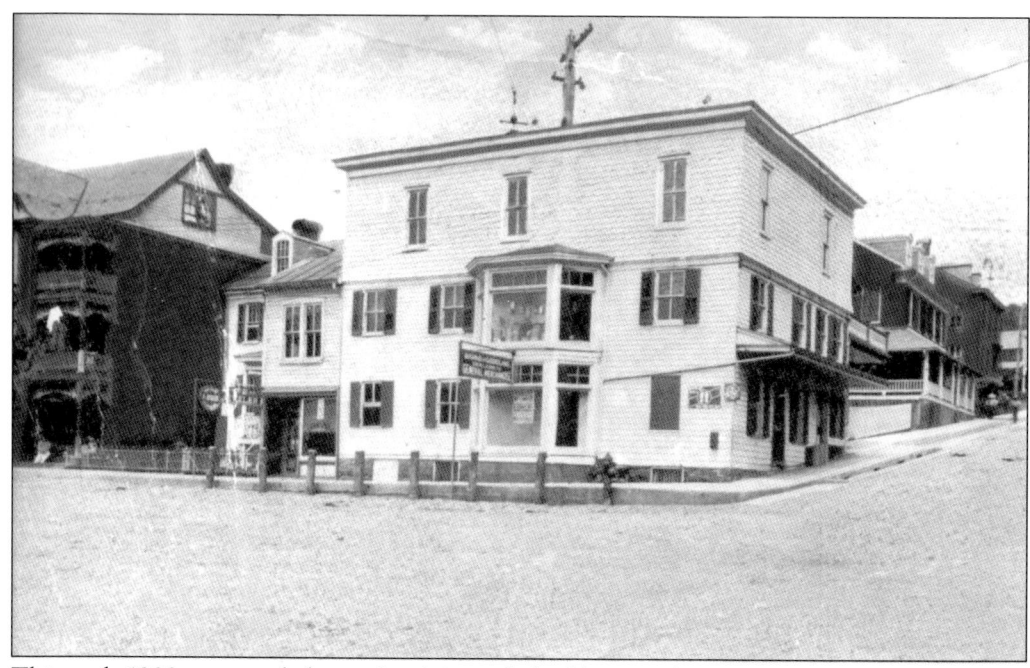

This early-1900s postcard shows the dry goods building at the corner of Church Street and Main Street after the peaked roof was replaced by another story. At the time of this picture, the building was occupied by Barnd and Goodling General Merchandise. On the left side of the picture at the rear of the building is a jeweler's shop. (Courtesy Bob and Fran Keller.)

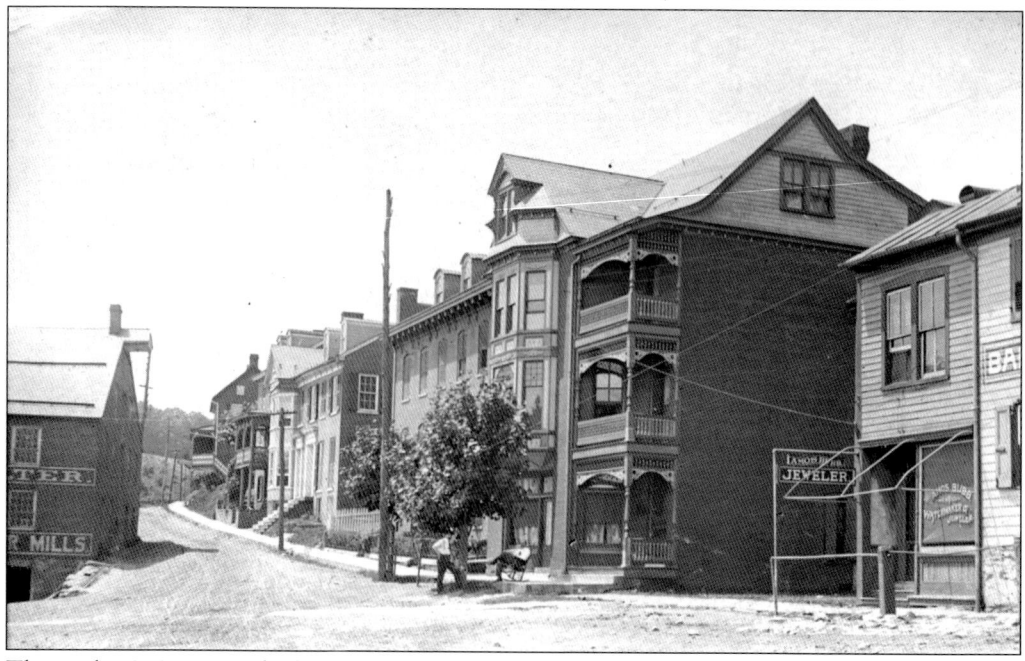

This early-1900s view is looking northwest toward Centerville. To the left is a portion of what is today the Glen Rock Mill Inn. To the right is the jeweler's shop that was operated by Amos S. Bubb. Percy C. Allison and John E. Yost also had jeweler shops at this location. (Courtesy Steven C. Grove.)

The beginning of the end is pictured in May 1966. Above, a dump truck can be seen backed into the front of the house as demolition begins on the buildings that occupied the corner of Church Street and Main Street. The building at the extreme left housed Garver's TV Sales and Service and, in earlier years, Glen Rock State Bank. Below, the buildings have been razed, and a front-end loader has been moved in to begin removing the debris. Once the debris was moved, a parking lot was built for Glen Rock State Bank. (Courtesy Keller-Brown Insurance Services.)

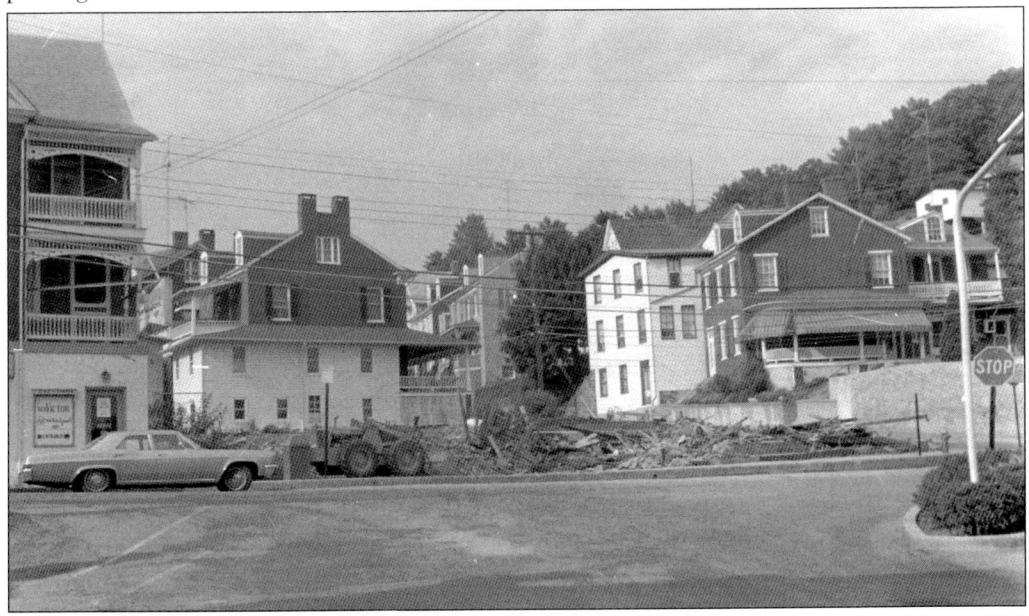

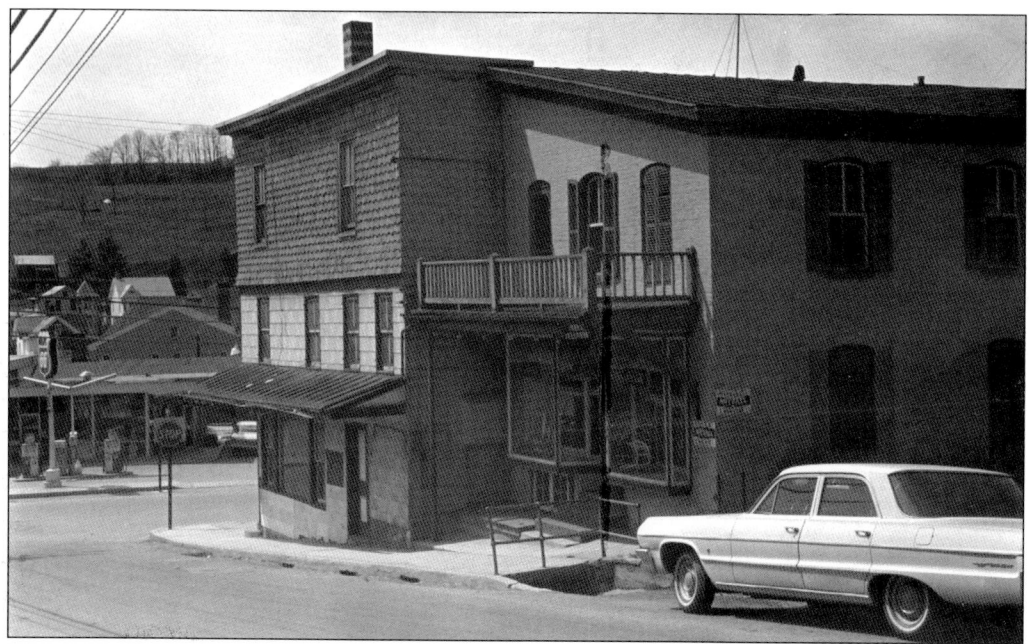

Here are other views from a different direction of the demolition at Church Street and Main Street. Above, it can be seen that the 100-year-old former dry goods and restaurant building had fallen into disrepair. Below, with the buildings down, the gasoline pumps in front of the Seigman-Wherley building on Water Street can be clearly seen. At the foot of Church Street across Main Street is the Phillips 66 gasoline station where the former railroad station once stood. (Courtesy Keller-Brown Insurance Services.)

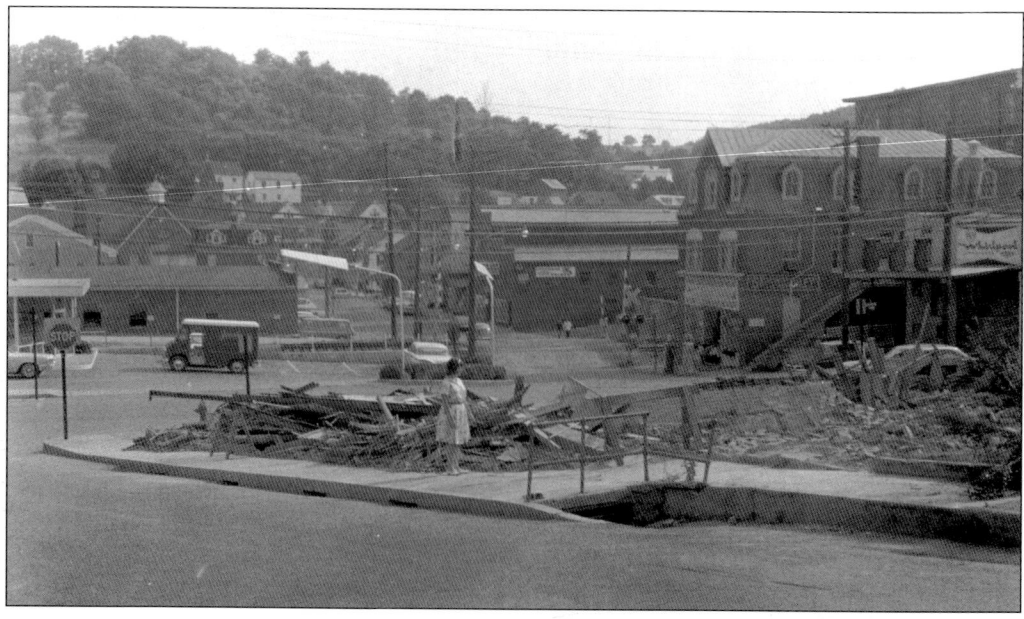

This early-1900s photograph of Main Street shows the Hotel Glen on the left and the corner of the railroad station on the right. Beyond the hotel is the Glen Rock State Bank. It used this location for only about a year before moving farther up Main Street beyond Church Street. (Courtesy Ed Hughes.)

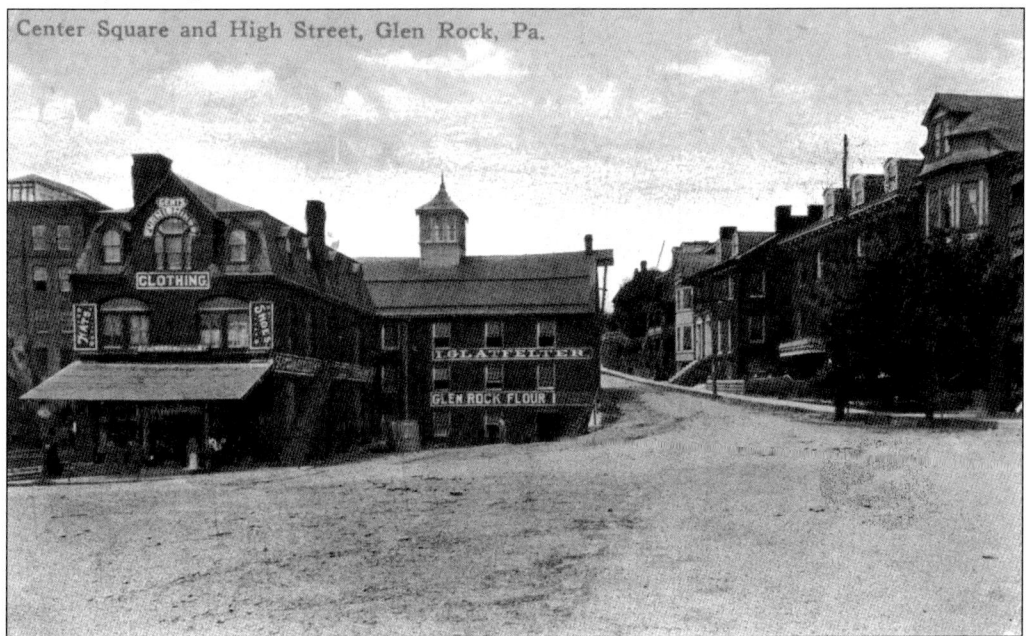

This early-1900s postcard shows the mill, now the Glen Rock Mill Inn, which was operated by Israel Glatfelter. The storefront on the left was Seigman and Wherley's. The store operated for many years as a men's furnishings store. To the far left in the background is the carriage factory. (Courtesy Steven C. Grove.)

25

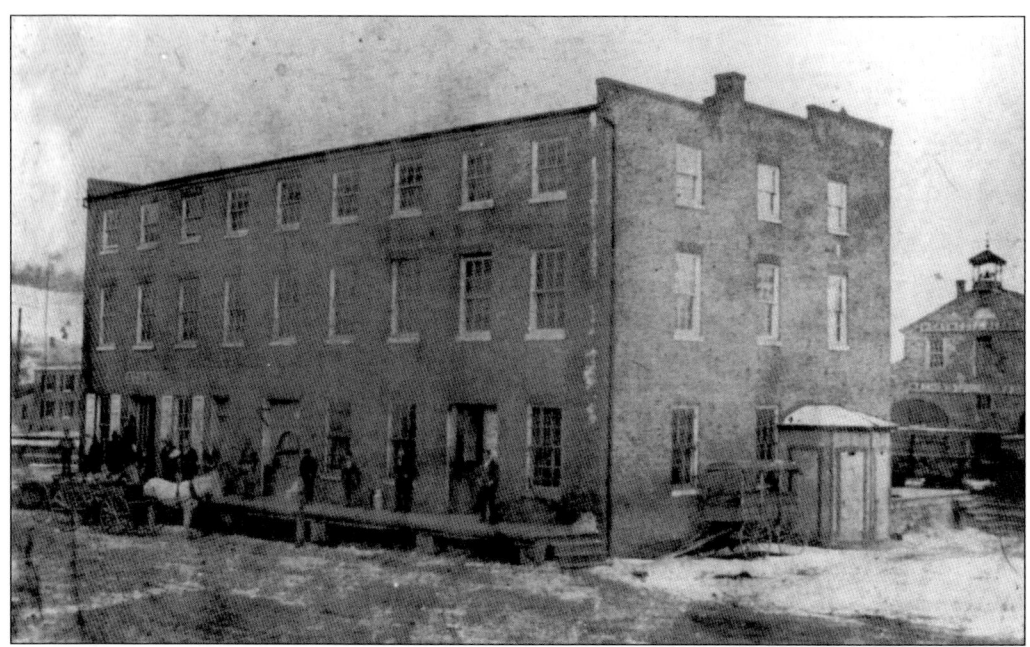

The railroad was a major influence in the development and the growth of Glen Rock. In 1856, Emanuel Sheffer erected this building on the site now occupied by the Getty Mart. In the 1800s, the building contained railroad offices, the First National Bank of Glen Rock, the post office, a large public meeting hall, and numerous mercantile businesses. In 1874, the Northern Central Railroad bought the building at a sheriff's sale for its use. The late-1800s photograph above shows the building from the Main Street side. The sign above the door near the left side reads "Store." The photograph below shows freight cars against the station platform for either loading or unloading. The picket fence enclosure near the bottom left of the picture was for holding livestock. The cattle pens were removed in 1907. (Courtesy Steven C. Grove.)

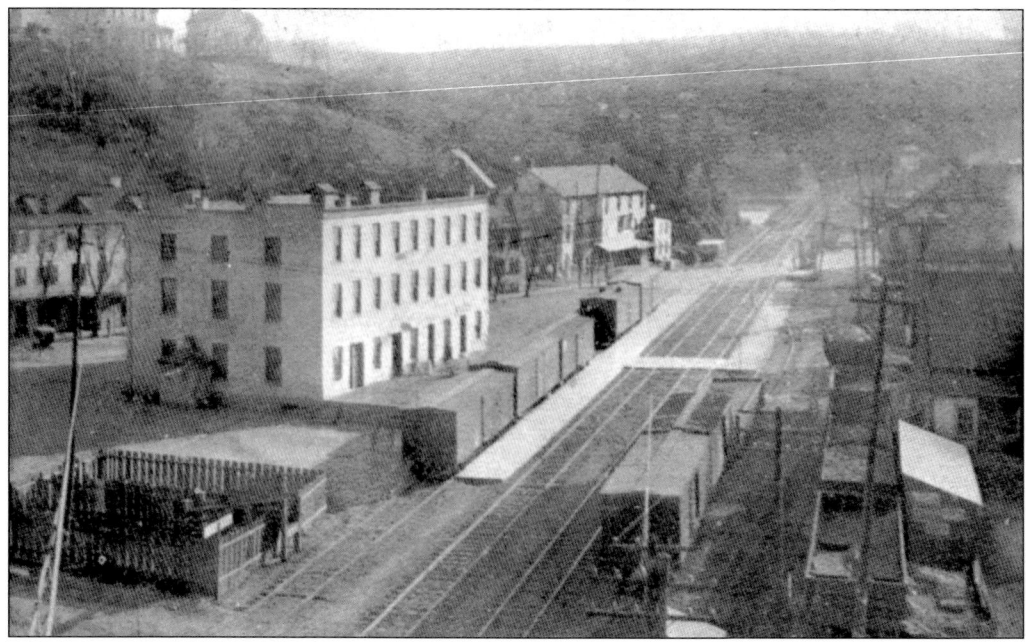

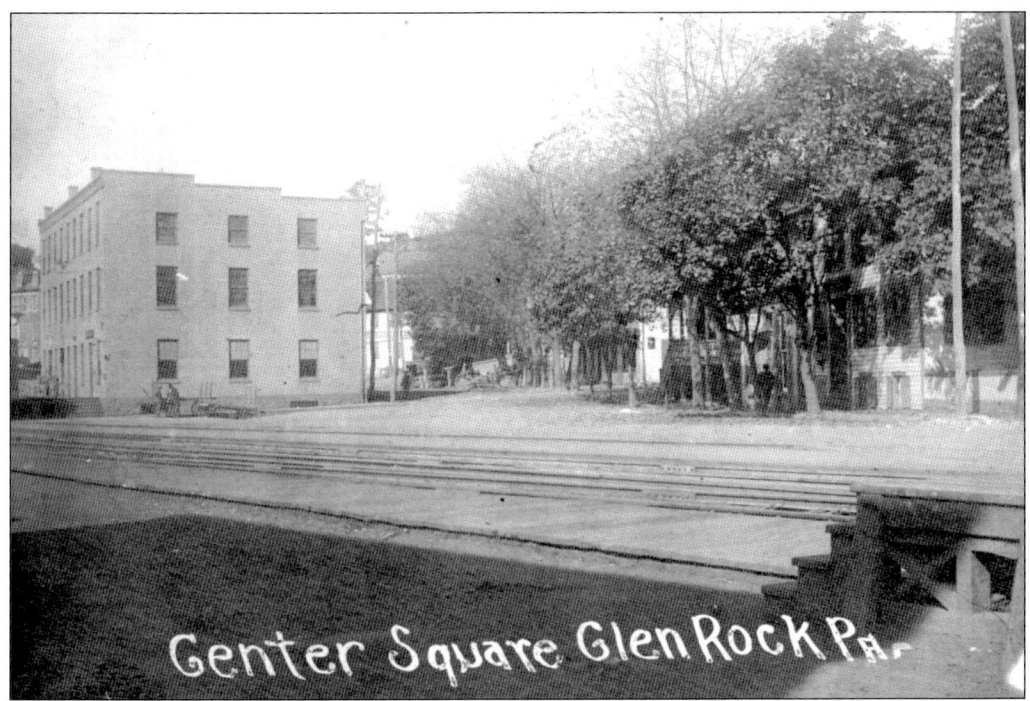

These old photographs show how imposing the railroad building was on Main Street in downtown Glen Rock. The building was so large and jutted into the street so far that it created a choke point for traffic on Main Street. The photograph below especially shows the narrowness of Main Street at the corner of the Emanuel Sheffer building. Also in the photograph below, note the flagman at the crossing awaiting the approach of a train. On the right side of Main Street is an advertisement for Acorn Stoves and Ranges and just beyond that is a tombstone business. (Above, courtesy Steven C. Grove; below, courtesy Keller-Brown Insurance Services.)

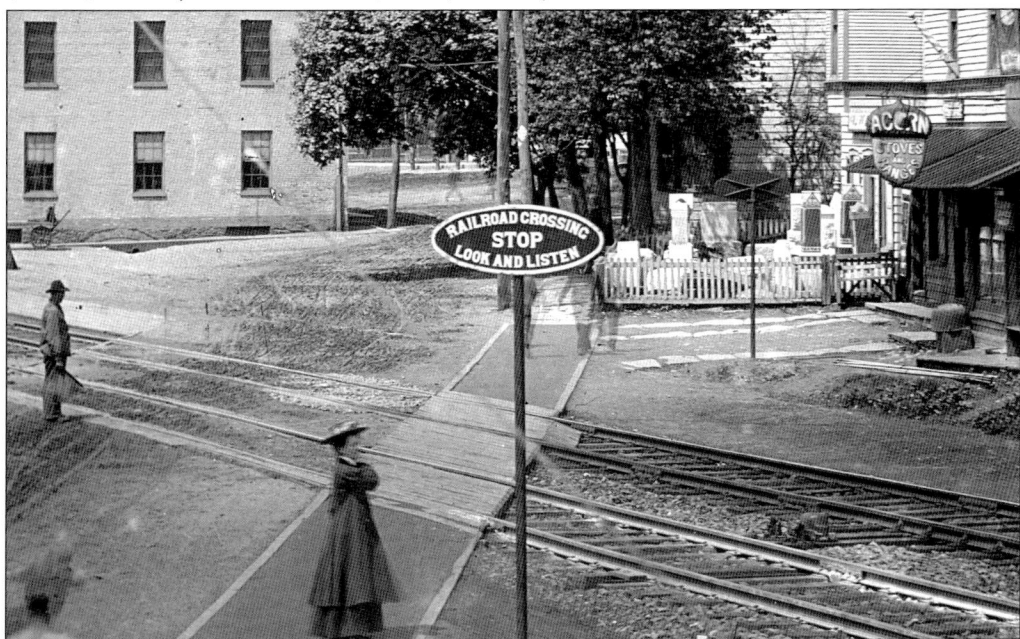

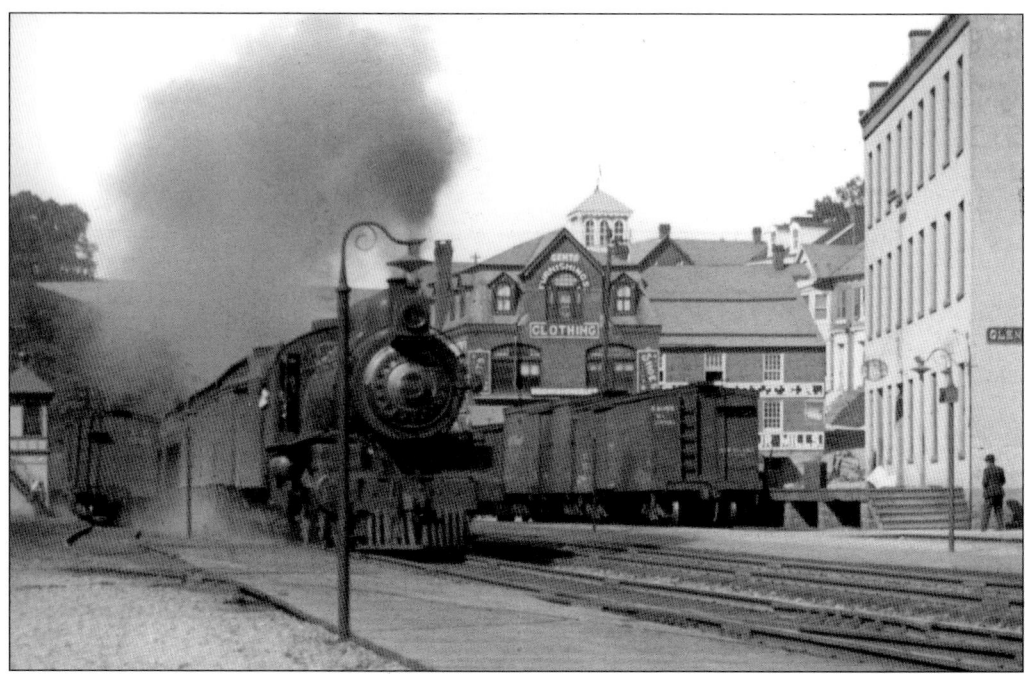

The photographers that took these two photographs were standing in nearly the same location. The above 1908 photograph was taken when freight cars were still being loaded and unloaded at the station platform. Judging from the years of the automobiles at right, the below photograph was taken in 1956 or after. By that time, the tracks adjacent to the station platform had been removed and baggage and freight carts were stored there. It is also interesting to note that the building is no longer neatly painted as it appears to have been in the older photograph that was taken in the railroad's more prosperous days. (Courtesy Ed Hughes.)

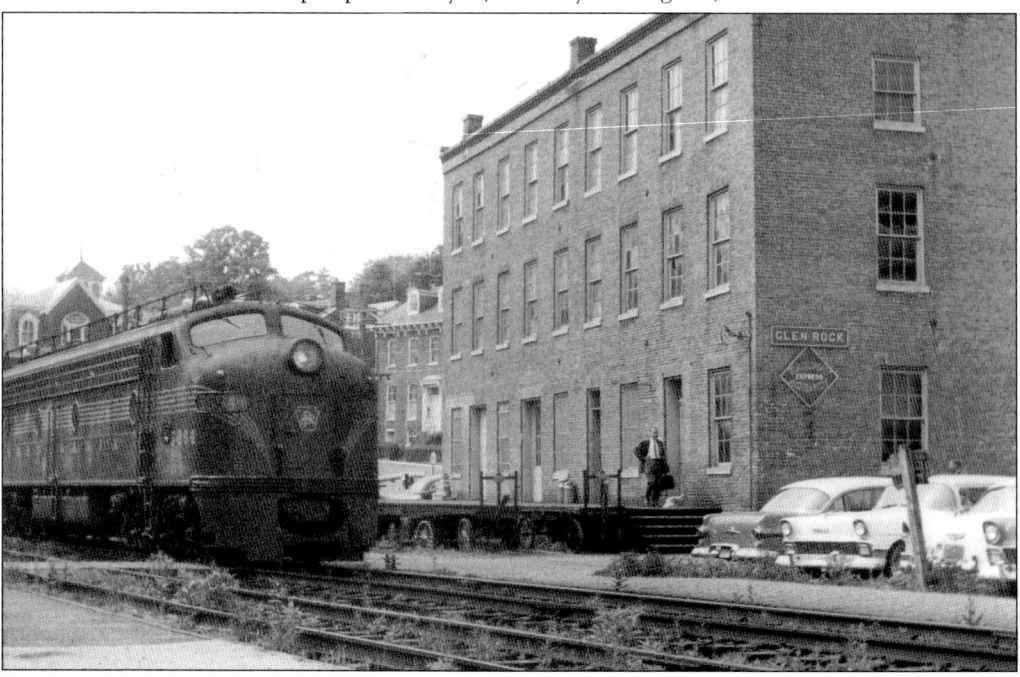

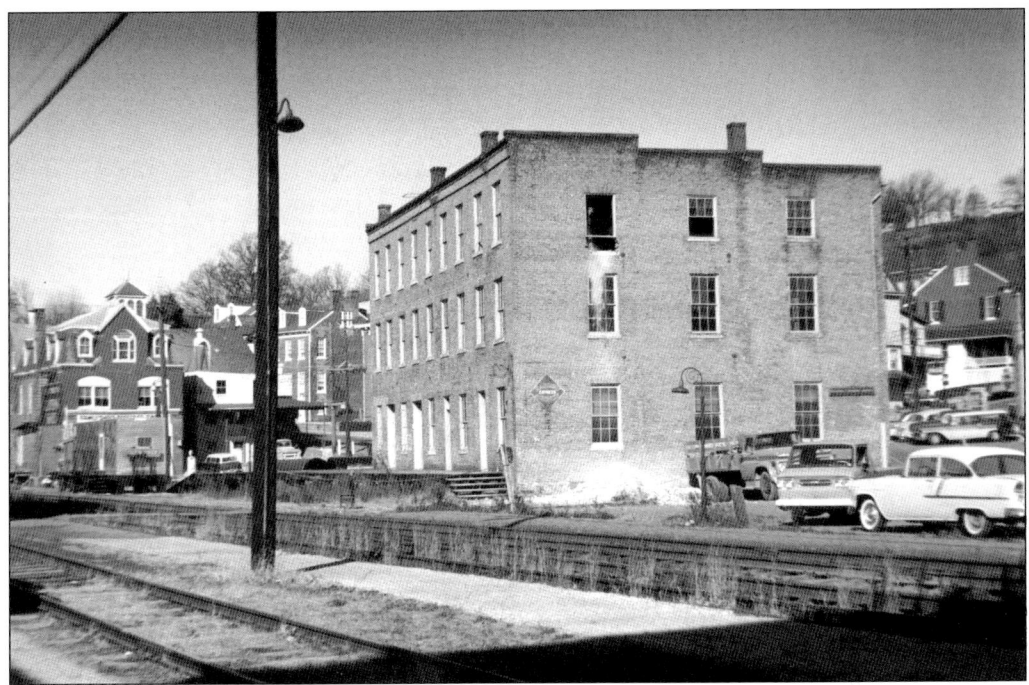

By late 1961, the former Emanuel Sheffer building had outlived it usefulness and demolition began. Passenger train ridership was significantly less than what it had been decades before, and roomy train stations were no longer needed. The photograph above shows the start of the demolition as the top floor windows are being removed. The photograph below was taken after the top two floors had been knocked down and only the first floor remained, revealing Neuhauses Hardware in the background. (Courtesy Keller-Brown Insurance Services.)

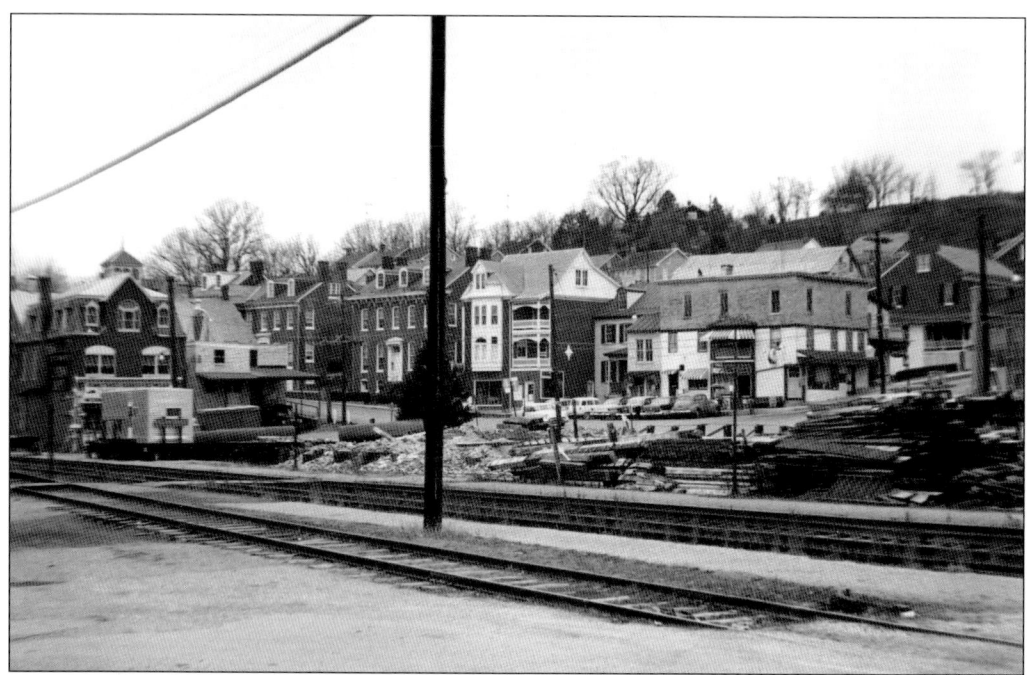

The removal of the train station made a drastic change in the appearance of the center square. After the debris was removed and the ground was leveled, a Phillips 66 gasoline station appeared. It is interesting to note in the picture above that there is an addition to the right side of the Seigman-Wherley business. A truck is parked at the loading dock under the overhang. Today that location is the courtyard of the Glen Rock Mill Inn. The photograph below shows that the Pennsylvania Railroad has installed a small trailer to serve as the passenger waiting room. On Main Street, a Reliance Motor Coach Company bus has just passed Geiple Funeral Home. The young girl wearing the hood observing the debris is Karen Zeichner. (Courtesy Keller-Brown Insurance Services.)

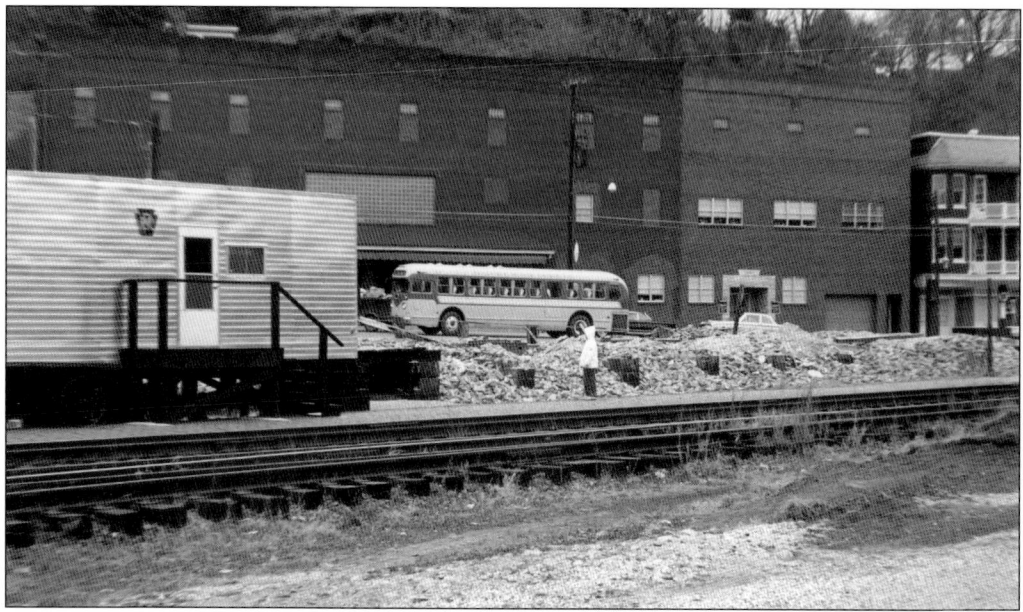

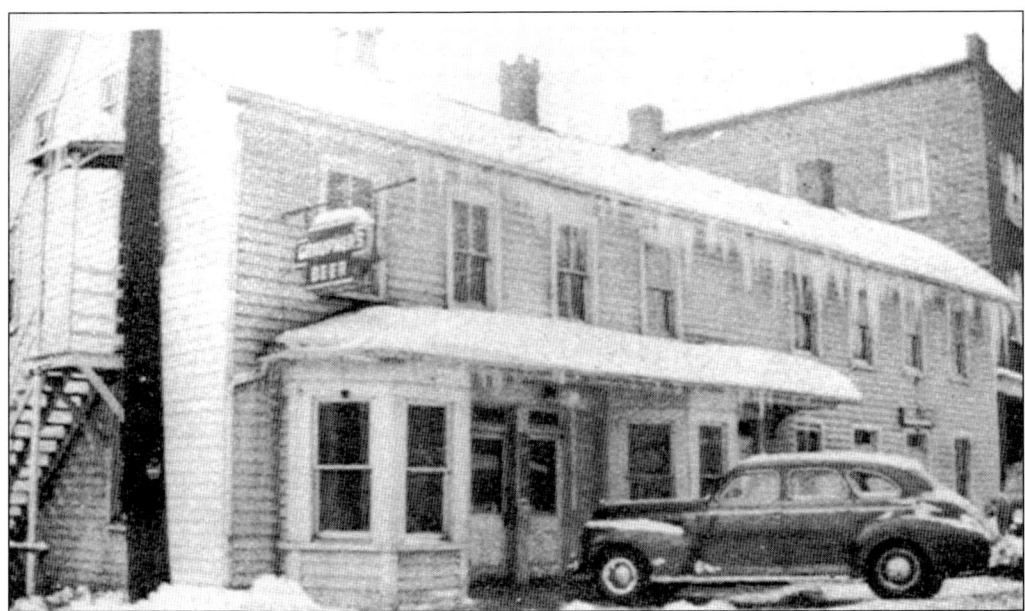

Across the railroad tracks from the old train station and to the left of Neuhauses Hardware was then 28 Main Street. Over the years, the building that stood at this location housed bars (including Whitey's), restaurants, an ice-cream factory, and a two-lane bowling alley. There was an icehouse behind the restaurant. In the photograph below, Neuhauses Hardware can be seen to the right. This site is now the parking lot between the Mignano Brothers Restaurant and the Arthur Hufnagel Public Library of Glen Rock. Note the railroad crossing gates that were used to protect vehicular traffic on Main Street. (Courtesy Bob and Fran Keller.)

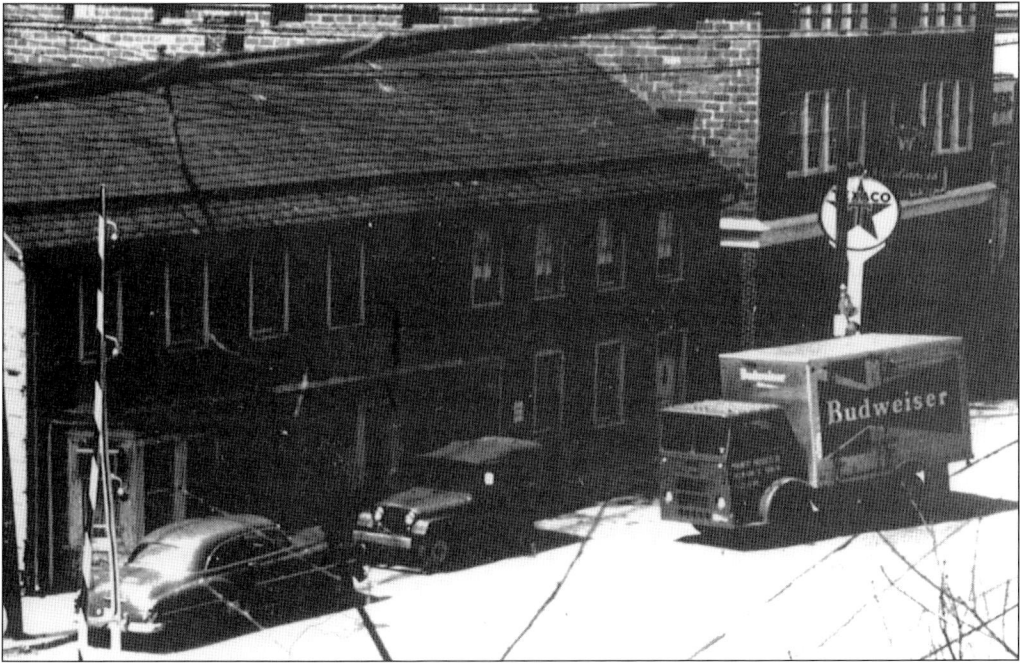

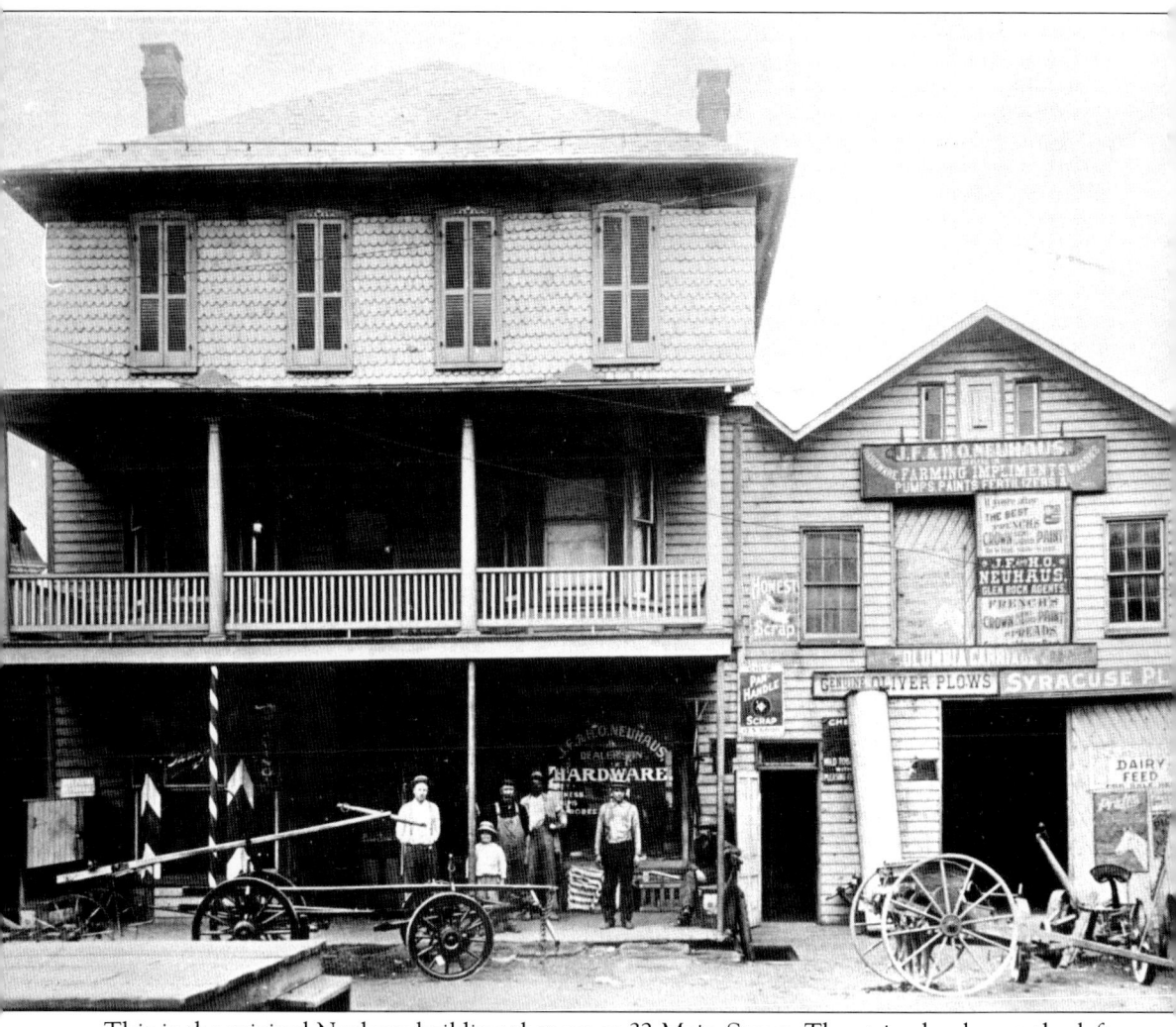

This is the original Neuhaus building that sat at 32 Main Street. The striped poles on the left side indicate that a barbershop was also at this location. The original proprietors were Jacob F. Neuhaus (left) and H. Oscar Neuhaus (right). This building was destroyed by fire on July 1, 1921. The company rebuilt at this location and remained in business until it closed its doors in the mid-1990s. (Courtesy Keller-Brown Insurance Services.)

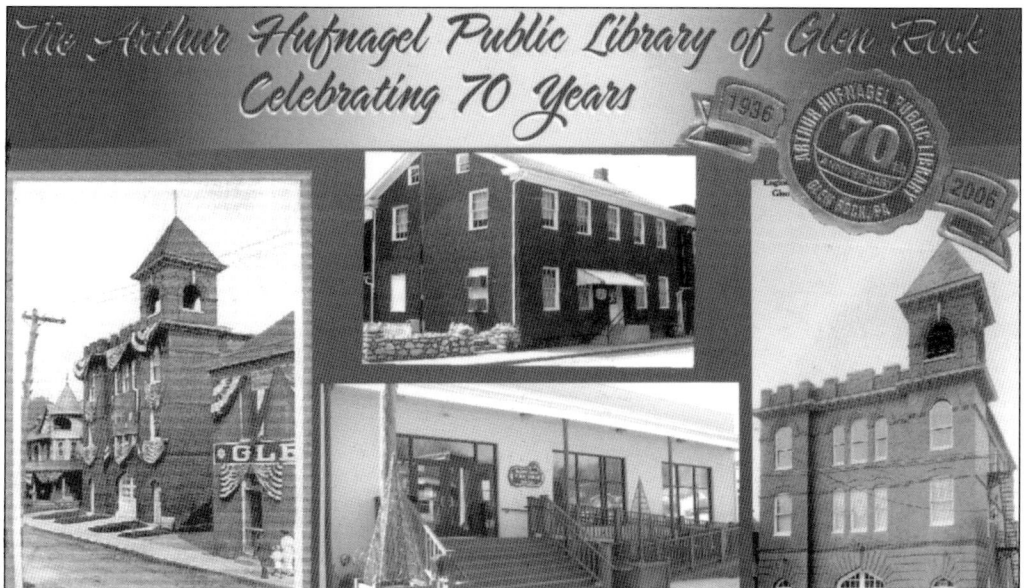

The Glen Rock Public Library was organized in 1936 under the sponsorship of the Glen Rock Lions Club. For the next 30 years, it was housed in the Glen Rock Fire Hall on Water Street. In 1966, the library moved to the Glen Rock community building on Baltimore Street, where it remained for the next 31 years. After Neuhauses Hardware closed, the library moved from the community building to the former hardware store. During the dedication of the new location in 1997, the library was renamed the Arthur Hufnagel Public Library of Glen Rock. (Courtesy Steven C. Grove.)

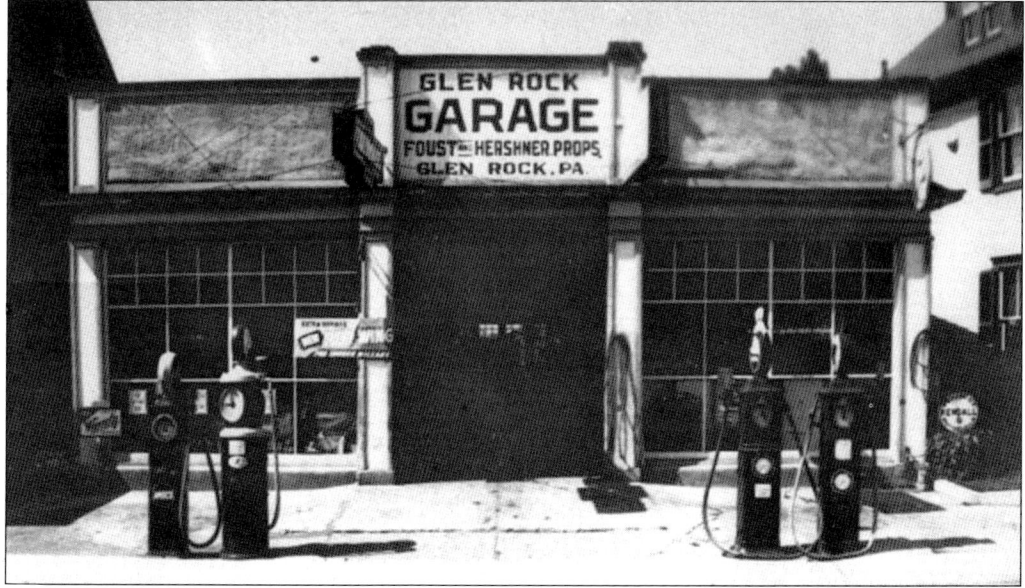

This was the Glen Rock Garage and Chevrolet dealership operated by Harry H. Foust and Fuhrman C. Hershner at 21 Hanover Street. A six-lane bowling alley later sat on this site until it was damaged by Tropical Storm Agnes in June 1972. Later a Western Auto store operated from this location. The Glen Rock Fire Company purchased the property in 1990. The building was used by the fire company as a social hall until it was removed in June 1990. (Courtesy Steven C. Grove.)

DESOTO AND PLYMOUTH CARS ARE ENGINEERED AND BUILT FOR LONG AND RUGGED USE

But.. Many Owners who are driving them far beyond their usual trade-in time assume they have reached their limit of usefulness.

● **DON'T LET NEGLECT RUIN YOUR CAR!**

Let us give it a scientific check-up. We'll render an honest verdict, which may be more pleasant than you now believe possible. Why not visit us today?

● MOST CARS GIVE MANY MILES OF GOOD SERVICE AFTER WE FIX THEM—FREE INSPECTION!

KELLER MOTOR SERVICE
Telephone 18-R-13

WATER STREET GLEN ROCK, PA.

OUR POLICY ★ To excel in Courteous Service ★ Use only Factory Engineered and Inspected Parts ★ Follow Factory Methods ★ Use special, labor-saving Tools

This is an advertisement for a Desoto-Plymouth dealership and garage operated by Kenneth A. Keller on Water Street. Note the old-style telephone number system that was used at the time. This was before Glen Rock changed to the four-digit system and, eventually, the seven-digit system. The site of this garage is now the Glen Rock Ambulance Club. (Courtesy Steven C. Grove.)

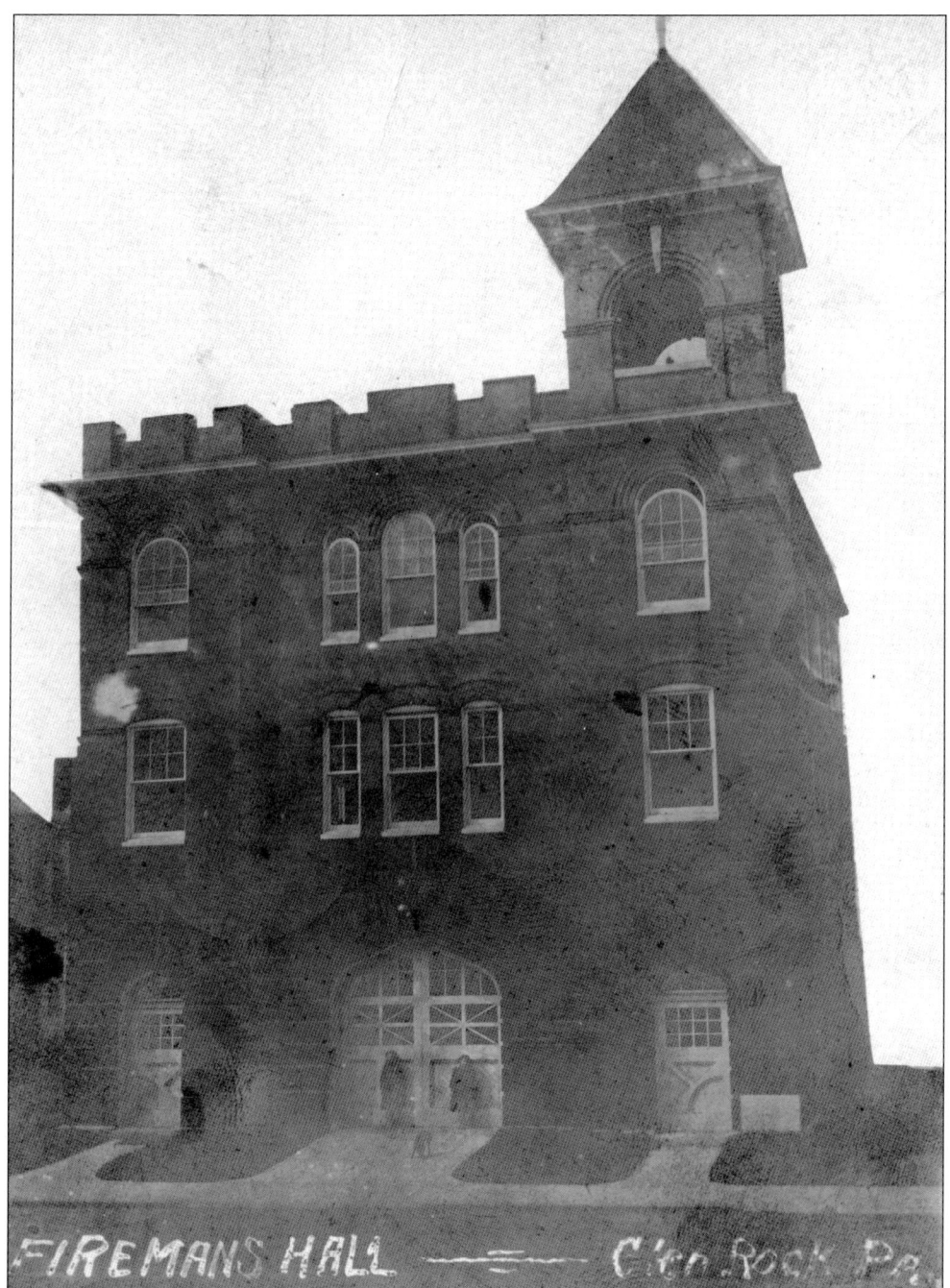

This is the Glen Rock Fire Hall on Hanover Street as it appeared in 1907. The building was erected in 1904 and immediately began serving the community in many ways. Through the years, the fire hall has been used for voting, festivals, dinners, and various fund-raising events. The town library was once located on the second floor. On the third floor, there was a basketball court, an electric theater, and a practice hall for the Glen Rock Carolers. The borough council, the Boy Scouts, and the American Legion have all met in the fire hall at one time or another. (Courtesy Steven C. Grove.)

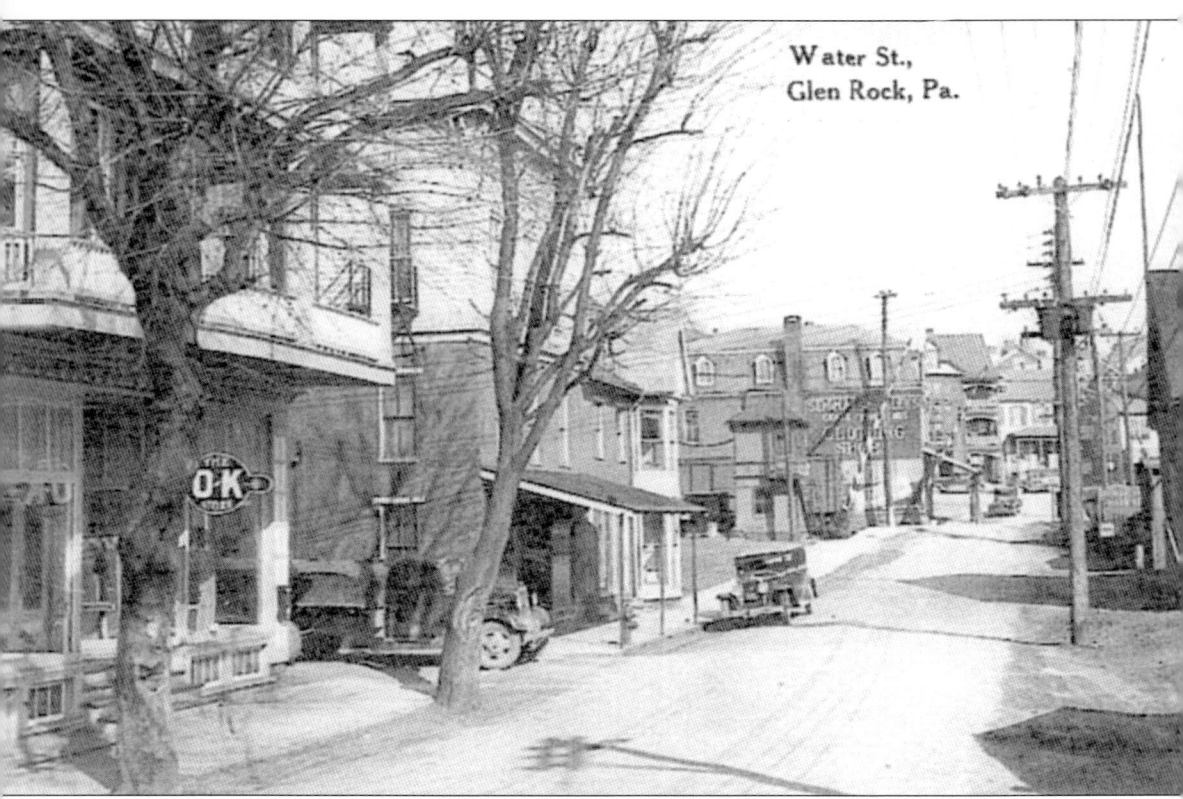

This 1930s photograph of Water Street looking toward Main Street shows the OK Store on the left at 30 Water Street. Various owners sold general merchandise from the store from 1920 to 1977. Later it was a bakery, a card shop, and a laundromat. Further up Water Street on the left, the railroad tower can be seen just before the crossing. (Courtesy John and Jane Shriver.)

Wesley C. Koller began erecting the Cosmo Carriage Company building in 1900 and opened it in 1901. The company resulted from a smaller buggy manufacturing business that Koller had started 10 years before. At first, the company seemed to thrive. Cosmo employed 75 men in the spring of 1904, but by summer, foreclosure proceedings were initiated by its creditors. The structure later became the Coleman Enterprise building. (Courtesy Steven C. Grove.)

Dr. Guy F. Stover had his dentist office on the first floor, and Wagner's Cleaners operated at the rear of 12 Manchester Street. In previous years, Dr. Clyde L. Seitz and Dr. Joseph Skelley made the location both their office and their residence. Beginning in 1981, attorney Jeffery Bortner had an office here. (Courtesy Keller-Brown Insurance Services.)

Just north of Glen Rock borough is Centerville. This aerial view of Centerville shows the gasoline stations, garages, and car dealerships at the intersection of Pennsylvania Route 216 and Pennsylvania Route 616. Pictured clockwise from the top center is the Sotdorus Texaco operated by Calvin Sotdorus; Sheppard's Ford dealership, which moved here in 1923; Strassbaugh Pontiac, which opened in 1955; and the Centerville Service Station, which was operated by Norman Rohrbaugh. (Courtesy Calvin Sotdorus.)

This is a late-1940s view of the Sotdorus station when it was a Tydol station. Later it became a Flying A station and then the Texaco station. At the time of this photograph, the station had three work bays. Note the rack of oilcans that were at the ready between the gasoline pumps. (Courtesy Calvin Sotdorus.)

This 1970s view of Sotdorus Motor Company was taken after two more work bays were added to the garage and the business changed to selling Texaco gasoline. Note the tires that are displayed for sale curbside on the right side of the building. The brick building that can be seen jutting above the roof on the right was the Glen Rock telephone exchange. It moved from Manchester Street to this location in 1949. (Courtesy Calvin Sotdorus.)

East of the intersection of Pennsylvania Routes 216 and 616 on the north side of Pennsylvania Route 216 was Glen Motor. Oscar Sharp operated an International dealership at this location in the 1960s. Later it became Reynolds and Whitcomb Auto Parts. (Courtesy Calvin Sotdorus.)

Two
CHURCHES AND SCHOOLS

This is the original Zion Lutheran Church at the corner of Water Street and Hanover Street. The church was built in 1862 and razed in 1905. The men standing against the church from left to right are Henry S. Bollinger, William W. Seitz, and Theodore Cramer. This 1905 photograph is alleged to have been taken just before demolition of the structure began. (Courtesy Steven C. Grove.)

The 1908 postcard at left shows the new Zion Lutheran Church on the corner of Water Street and Hanover Street. The first worship service was held in the Sunday schoolroom on December 24, 1905. It took most of 1906 to complete the interior work, and it was not until December 23, 1906, that the first worship service was held in the sanctuary. The photograph below shows a gathering of the congregation about 1910. The store across the street from the church was Theodore Cramer's. The Lutheran church and buildings visible across the street were all heavily damaged by the floodwaters of Tropical Storm Agnes. (Courtesy Steven C. Grove.)

These postcards show early views of the Trinity Reformed Church that was erected on Manchester Street in 1895. Because the congregation was small, they began meeting in the Methodist church about 1874 and later in the Lutheran church. They felt that they could attract more new members and a full-time pastor if they built a church of their own. The photograph below shows the church as it appeared in 1909. This church has been renovated several times over the years, and it is now known as the Trinity United Church of Christ. (Courtesy Steven C. Grove.)

IMMANUELS' EVANGELICAL CHURCH OF GLEN ROCK, PA.

The Immanuel Evangelical congregation built the church shown above on New Street in 1870. The congregation outgrew the church by the 1920s, and it was necessary to find a way to expand the building at the current location or move to another. The congregation decided to expand at the current location, and an ingenious plan was developed that resulted in the church being rebuilt as it appears below. (Courtesy Steven C. Grove.)

Immanuel Evangelical Church, Glen Rock, Pennsylvania

These 1926 photographs show how the congregation went about expanding the church on the present lot. The old church was razed except for the left wall. The left wall of the old church then became the back wall of the new church. The heavy bracing of the saved wall can be clearly seen in both photographs. Construction was then begun on the front portion of the church, and it progressed back to meet the braced wall. This church is now Immanuel United Methodist Church at the corner of Church Street and New Street. (Courtesy Steven C. Grove.)

Glen Rock's public school in 1860 was located at the corner of Water Street and Hanover Street. In 1870, this school was constructed between Baltimore Street and Manchester Street on two parcels of ground. One parcel was purchased from William Heathcote and the other from William Sheffer. (Courtesy Arlene O. Keller.)

The trees in this photograph indicate that it was taken close to either the very beginning or the very end of the school year. The windows of the school are open, indicating that it was a very hot day. The clarity of the trees indicates that no wind was blowing at the time. (Courtesy Keller-Brown Insurance Services.)

This undated photograph was taken on a hillside near the school. The leaves on the ground indicate that it is probably mid-autumn. Little is known about the identity of the students and the teacher, except that Lida Rohrbaugh is standing in the last row on the far left. (Courtesy Kerry and Deb McKnight.)

This May 1966 photograph shows the school at the top of the hill in a different configuration as a result of the extensive renovations that were done in 1923. The peaked roof was replaced with a near-flat roof to expand the inside dimensions of the top floor. Also of note in this picture is the Roser building that was built in 1870 for manufacturing furniture. In recent years, it was known as the Glen Rock Variety Store. It was being used for apartments when it was gutted by fire on March 18, 1999. The windows with awnings on the left side at 4 Manchester Street are where Dr. C. W. Zeichner had his optometry office. (Courtesy Keller-Brown Insurance Services.)

Before the establishment of efficient student transportation systems, it was necessary for students to attend school short distances from home. This September 4, 1906, photograph is of a one-room schoolhouse on Krebs Road outside Glen Rock. There were many one-room schoolhouses in southern York County. Many survive today, and they are used as private residences. The photograph below shows the same schoolhouse still being used more than 100 years later. (Courtesy Nellie Moser.)

50

When it became necessary to consolidate the upper grades of the smaller schools of Shrewsbury Township, Codorus Township, and the boroughs of Glen Rock, New Freedom, and Shrewsbury, a site for the new facility was chosen along Fissels Church Road just outside Glen Rock. The photograph above shows the early stages of construction on the new high school in 1951. The photograph below shows the school soon after completion. Several improvements and renovations have made drastic changes to the outward appearance of Susquehannock High School. The high school opened in 1951, and its first graduating class was in 1952. Years later, Southern Elementary School was built to the left of the high school, and Southern Middle School was constructed to the right. (Above, courtesy Kerry and Deb McKnight; below, courtesy John Hufnagel.)

This is the 1920–1921 class of the Bonnair School, one of several small country schools in the Glen Rock area. Pictured from left to right are (first row) Logan Lackey, Hilda Thomas, and Melvin Hilker; (second row) Lola Bowser, unidentified, Romaine Hummer, George Lackey, Ann Fair, and Jenny Thomas; (third row) William Garrett, Josephine Flinchbaugh, Russell Bowser, Pearl Meckley, unidentified, and Nellie Lackey; (fourth row) Walter Thomas, Lillie Bowser, Leon Fair, Ruth Lau, Stewart Thomas, and unidentified. (Courtesy Frank Ingham.)

The Glen Rock High School class of 1942 is pictured here. From left to right are (first row) Willson Day, Joyce Krout, William Anstine, Audrey Grove, Henry Stover, Millred McMillian, Myrl Bollinger, and Erlene O'Keefe; (second row) Doris Forwalt, Lamar Warner, Charlie Allison, Anna McCullough, Earl Dubbs, Gordon Forman, Emma Stabler, and Josh Krebs; (third row) Francis Kreb, Richard Black, Grace Seitz, Rich Henry, Jean Burwagger, Benard Shaffer, Grace Carson, Eugene Allison, and Lorraine Krout; (fourth row) Marvin Lentz, George McCullough, Roger Smith, Artus Fishel, Richard Reider, Gordon Murganfetter, John Lackey, Lloyd Dubb, and Arthur Dise. (Courtesy Earl and Anna Dubbs.)

This report is to be delivered to the parents or guardians for their inspection and signature; after which, it is to be returned to the teacher.

We ask you to carefully examine each item in this report and by the per cent. attained in the different subjects note the quality of work your child is doing.

Realizing the necessity of the home and school working together in perfect harmony, we solicit your earnest co operation in all things, that are for the best interests of those who have been intrusted to your care as parents and to our care as teachers.

See that your children are in school every day that it is possible for them to be there.

Regular visits of the parents to the schools would be a source of encouragement to both teachers and pupils.

INTERPRETATION OF MARKS.
GROUP SYSTEM.

E—Excellent—to be given only when work is perfect in all respects or to indicate work of superior excellence
G—Good—to indicate work that is well and thoroughly done.
M—Medium—to indicate work of a lower degree of excellence but still acceptable to the teacher.
D—Doubtful—to indicate a doubt in the teacher's mind as to the nature of the pupil's work. This mark should cause the parent to pay some attention to the child's work.
F—Failure—to indicate work that is unsatisfactory to the teacher and shows that the child has failed in his or her studies thus marked. When this mark is given parents and teachers should attempt by consultation and co-operation to obviate the difficulties.

PER CENT. SYSTEM.
95—100—Excellent; 85—95—Good. 75—85—Medium; 70—75—Doubtful; below 70—Failure.

—REPORT OF—

Lawrence Rohrbaugh

A PUPIL

—OF—

~~Sixth~~ 7th Grade

Room No. 1

School Building Glen Rock

Grace Brooks Teacher.

The School Law fixes a school month as 20 days Each page of this report covers this period.

KURTZ BROS.,
DEALERS IN SCHOOL SUPPLIES,
CLEARFIELD, PA.

Pictured here is a 100-year-old report card printed by Kurtz Brothers of Clearfield. The Glen Rock school report card belonged to Lawrence Rohrbaugh when he was in the seventh grade during the 1908–1909 school year. The encouragement to the parents or guardians to get involved in their child's education is very similar to the encouragement that is given today. The report card shows the variety of subjects that were taught then. It is curious to note that the student's last name was Rohrbaugh; however, the parent's signature on the report card is Rohrbach. Rohrbaugh died four years later of scarlet fever at the age of 16. (Courtesy Kerry and Deb McKnight.)

Reading,	93	Algebra,		Reading,	92	Algebra,	
Spelling,	81	Rhetoric,		Spelling,	83	Rhetoric,	
Writing,	90	Latin,		Writing,	89	Latin,	
Drawing,		German,		Drawing,		German,	
Language,		Geometry,		Language,		Geometry,	
Grammar,	88	Trigonometry,		Grammar,	81	Trigonometry,	
Phys & Hygiene,	85	Physics,		Phys & Hygiene,	85	Physics,	
Mental Arithmetic	92	Physical Geog.,		Mental Arithmetic	90	Physical Geog.,	
Arithmetic,	72	Geology,		Arithmetic,	92	Geology,	
Geography,	88	Botany,		Geography,	88	Botany,	
Composition,		History,		Composition,		History,	
U. S. History,	84	Book-Keeping,		U. S. History,	84	Book-Keeping,	
Civil Government,				Civil Government,			
Literature,				Literature,			
Classics,		Monthly Average,		Classics,		Monthly Average,	
Music,		Term Average.		Music,		Term Average.	
Days Absent,		Times Tardy,		Days Absent,	1	Times Tardy,	
Neatness,		Politeness,		Neatness,		Politeness,	
Behavior,	100			Behavior,	100		

E R Rohrbach E R Rohrbach

Three
LIFE AROUND TOWN

This is the Ox Roast Parade marching on Main Street toward center square around 1912. The band has just passed the Hotel Glen (formerly Cold Spring Hotel) shown here on the left. The structure at the extreme left is the Allison house, which was built on the corner of Church Street and Main Street by Bertrum Allison. (Courtesy Keller-Brown Insurance Services.)

Glen Rock was one of many towns around the United States that was home to a Civilian Conservation Corps (CCC) camp. The CCC was one of the many work-relief programs under Pres. Franklin D. Roosevelt's New Deal. The camp in Glen Rock was atop the hill at the end of what is now Camp Road. It operated from 1935 to 1942. (Courtesy Kerry and Deb McKnight.)

The Glenview Camp, Company 2318, at Glen Rock was established on June 26, 1935. The nucleus of the camp was formed by men of Company 305, who traveled to Glen Rock from Richmond Furnace. The young men lived in tents for almost four months until the wooden barracks were erected. This 1935 photograph shows Teresa Eason (left) and Florence Roser standing in front of tents in the camp. (Courtesy Kerry and Deb McKnight.)

The CCC provided work for young men between the ages of 18 and 26. Sam McKnight came to the camp from South Carolina. Here he met and married Florence Roser, who lived across the street from the camp on Glen Avenue. This photograph shows Sam and Florence standing in front of one of the buildings in the camp in 1936. (Courtesy Kerry and Deb McKnight.)

The CCC camp functioned as its own self-contained little town. A camp exchange was established in one of the wooden barracks to provide the men with the basic necessities. The camp began publishing its own newspaper, the *Glenview Echoes*, on September 5, 1936. When the United States entered World War II in late 1941, the need for men ages 18 to 26 in uniform was far more important than the civil work that they were performing with the CCC. The Glenview camp closed in 1942. (Courtesy Kerry and Deb McKnight.)

Pictured here is Glen Rock's first car. This is Wesley C. Koller driving his new Stanhope car into town on Manchester Street in June 1900. This steam-powered automobile had pneumatic tires and reportedly could reach the breakneck speed of 40 miles per hour. Note the tiller steering system and that Koller is operating the vehicle from the right side. (Courtesy John and Fran Spring.)

Another old-time automobile photograph (above) shows, from left to right, Marlet Roser, Helen Roser, and Florence Roser standing beside their father's new car in front of the family residence at 38 Glen Avenue. Seen at right, years later, Florence Roser (right) stands with her friend Teresa Eason beside another new automobile in front of 38 Glen Avenue. Of particular interest in that photograph is the "Sutliff Chevrolet, Inc." emblem on the spare tire. Sutliff Chevrolet is still in business in Harrisburg. (Courtesy Kerry and Deb McKnight.)

The Glen Rock Carolers are probably the most well-known commodity to come out of Glen Rock. Since 1848, the carolers have walked the streets of Glen Rock serenading the community with Christmas carols. Each Christmas morning, beginning exactly at the stroke of midnight, the carolers begin singing in the square at the intersection of Baltimore, Manchester, Hanover, and Main Streets. This picture was taken in 1962. (Courtesy Keller-Brown Insurance Services.)

At first glance, this looks like a picture of W. C. Fields from one of his movies. Not so. It is Daniel Krebs, a Glen Rock–area resident, with Dorothy Stermer in a 1949 *Baltimore Sun* Sunday paper article featuring the Glen Rock Carolers. The 101st year of the Glen Rock Carolers was marked in 1949. (Courtesy Daniel J. and Dorothy Mays.)

Above, this 1973 Christmas card shows the carolers singing in front of the home of Daniel and Dorothy Mays on Walnut Street. The card was made to commemorate the 125th anniversary of the carolers. Below, this 1996 Christmas card by the Glen Rock Jaycees featured a 1971 photograph by Gary L. Alcorn of the Glen Rock Carolers and townspeople on Main Street just past the Glen Rock Mill Inn toward Centerville. (Above, courtesy Daniel J. and Dorothy Mays; below, courtesy Kerry and Deb McKnight.)

Although Glen Rock was incorporated in 1859, the town chose to celebrate its first 100 years from July 30 to August 6, 1960. The Centurama shown on the banner was a historical pageant about Glen Rock's first 100 years. It was performed five times during the celebration week. This photograph clearly shows how the Pennsylvania Railroad building (formerly the Emanuel Sheffer building) protruded out into Main Street causing a traffic bottleneck. It was razed the next year. (Courtesy Keller-Brown Insurance Services.)

This is one of more than 50 floats that took part in the centennial parade on Saturday, July 30, 1960. The parade lasted two and one half hours and it included 15 bands. This is the Glen Rock Carolers float as seen from Terrace Heights while it proceeded slowly up Manchester Street. (Courtesy Kerry and Deb McKnight.)

This is Diane McKnight in 1860s dress and bonnet during the centennial celebration week in 1960. She is most likely in costume for the old-time fashion show that was held near the end of the week at the Susquehannock High School athletic field outside of town. In addition to the fashion show and the Centurama, the athletic field was also used for the fireworks finale on Saturday, August 6. (Courtesy Kerry and Deb McKnight.)

These are two snowy views of the same house at 7 Terrace Heights. The photograph above was taken about 1930. The double house was owned by Roye Bixler, son of William O. Bixler. The photograph below was taken about 30 years later after the shutters were removed and the house was painted white. Kerry McKnight grew up in this house, and that is him standing on the front porch. (Above, courtesy Steven C. Grove; below, courtesy Kerry and Deb McKnight.)

This late-1950s winter photograph was taken on Glen Avenue. The CCC camp was to the photographer's right. Glen Avenue was recently extended through the field that can be seen in the distance, and new homes now occupy that hill. Snows like this have always been a challenge to the residence of Glen Rock because of the town's typography. The majority of Glen Rock residents live either on or near a hill. (Courtesy Kerry and Deb McKnight.)

The railroad was a big part of Glen Rock through the years. Trains brought in raw materials and took out the finished products. Because Glen Rock sits lower on the grade from New Freedom, helper engines were stationed at Hanover Junction and then moved when needed to Glen Rock to assist the longer and heavier trains up the hill to the summit. Walkers and bikers using the Heritage Trail probably can not imagine why a powerful steam engine can not negotiate the climb. By railroad standards, the climb to New Freedom is long and steep. Shown here are two of the helper steam locomotives that were stationed at Glen Rock. (Courtesy Ed Hughes.)

The purpose of this early-1900s photograph is not known. It appears to be either a school event or an excursion of some type. The white sign on the passenger car reads, "The Pennsylvania State College in co-operation with the Pennsylvania Railroad Company, the Pennsylvania State Highway Department, Office of Public Roads, U.S. Department of Agriculture." (Courtesy Arlene O. Keller.)

On Good Friday, April 2, 1920, a passenger train derailment at Centerville killed one train engineer and injured three train crew members and a passenger. The accident happened when a spring hanger broke on the lead helper locomotive. The engineer who died was William H. Dehuff of Baltimore, Maryland. Ironically, Dehuff's son Walter F. Dehuff was superintendent of Read Machinery in Glen Rock, and he lived close to the scene of the accident. Because it was Good Friday, ridership on this train was down. It usually carried school students between York and Glen Rock. (Courtesy Miriam Bradfield.)

Metropolitan-Edison workers pose at the company's facility on Baltimore Street in November 1950. The workmen used the facility as their base of operations while they performed electrical work in the Glen Rock and Shrewsbury township area. Today the building is the brick structure that is painted yellow across Baltimore Street from the old sewing factory. From left to right are Joshua Ingham, Millard Koller, Charles Beck, and James Taylor. (Courtesy Frank Ingham.)

Austin Leonard Grove was born in Glen Rock in 1892. He graduated as valedictorian of his 1903 Glen Rock High School class. Grove studied at Franklin and Marshall College where he graduated in 1913. He later became principal of Terre Hill High School in Lancaster County. He was a member of the faculty at Franklin and Marshall College when he was inducted into the army. Grove was killed in action on September 28, 1918, at Montfaucon while fighting with the 313th Infantry Regiment during the Meuse-Argonne offensive. Glen Rock American Legion Post 403 was named in Grove's honor on November 20, 1919. (Courtesy American Legion Post 403.)

American Legion Post 403 began meeting in the Glen Rock Fire Hall on Hanover Street. The post purchased the building (above) at 30–32 Hanover Street from Howard and Eva Rohrbaugh on March 31, 1945. The post moved from Hanover Street to its current location at 4035 Manchester Street on August 30, 1995. Below is the removal of the antitank gun from the old post for restoration before it was placed at the new post. The removal was done by Sotdorus Motor Company. The man with his hand on the barrel is Calvin Sotdorus. (Courtesy American Legion Post 403.)

This 1916 postcard view of Pennsylvania Route 616 (Main Street Extension) is between Glen Rock and Centerville. This view should look familiar to anyone who travels this route. The bridge in the picture still exists. It carries traffic across the creek at Prince Kitchens. (Courtesy Arlene O. Keller.)

This 1916 postcard view of Pennsylvania Route 616 (Baltimore Street) was taken near the old Heathcote mill. The similarities between the automobile and the driver in this picture and those in the postcard above indicate that the driver was working with the photographer to stage these scenes. (Courtesy Steven C. Grove.)

Glen Rock native Rob Mays, a graduate of Susquehannock High School, is an accomplished downhill and cross-country skier. Shown here during one of his many competitions, Mays was a ski guide and counselor at Sun Valley, Idaho. He is one of many Glen Rock natives who excelled in a sport. (Courtesy Daniel J. Mays.)

There is standing room only here. In this case, it appears that there are more fans standing than sitting. This was Glen Rock's baseball field at the top of Hanover Street near the Lutheran cemetery. Before many of the daily distractions that are known today, baseball occupied the interest of nearly everyone in Glen Rock. (Courtesy Steven C. Grove.)

The Southern York County Baseball League was founded before 1900. Nearly every town in southern York County fielded a team in this league, including Glen Rock, Loganville, New Freedom, Seven Valleys, Shrewsbury, and Stewartstown. Glen Rock's team was sponsored by William O. "Pop" Bixler, who made his cigar store on Hanover Street the unofficial headquarters of the team. (Courtesy Daniel J. Mays.)

This is a 1908 scorecard that was used for Glen Rock home games. Notice that many of the player's names listed on the scorecard are still well known in Glen Rock and the surrounding area. The scorecard is also similar to scorecards, programs, and sports tickets of today; it encourages patronization of local businesses. (Courtesy Daniel J. Mays.)

I. Palmer Diehl was born in 1877. By 1894, when he was just 17 years old, Palmer had proven himself to be an accomplished ballplayer. He played shortstop on the Glen Rock team that fielded players several years older than him. Palmer was also a caroler for two years, and he played the coronet. Palmer died at age 71 in 1948. (Courtesy Daniel J. Mays.)

The 1920 Glen Rock baseball team is pictured here. From left to right are (first row) Clair Allison, Edward Heyn, Hap Shaffer, Tub Bollinger, unidentified, Milt Diehl, and unidentified; (second row) Sherman Seitz, two unidentified, Edward Seiling, three unidentified, and Orin Dise. (Courtesy Daniel J. Mays.)

Pictured here is the 1930 Glen Rock baseball team. From left to right are (first row) Max Grothe (business manager), Lowell Rohrbach, Roger Rohrbaugh, Ken Jones, Flethcher Seitz (batboy), Hen Mickey, Pup Moody, Grover Kerchner, and Milt Diehl; (second row) Park Rohrbaugh (manager), Dub Moody (scorekeeper), Walter Taylor, Evans Mickey, Joe Bierly, Barto Sweitzer, Tub Bollinger, Mr. Krout, Jim Seiling, and Henry Dise (coach). (Courtesy Daniel J. Mays.)

Glen Rock native Clifton Heathcote graduated from the town's two-year high school in 1914. In 1918, he signed a Major League Baseball contract with the St. Louis Cardinals. In 1922, the Cardinals played a morning/afternoon doubleheader with the Chicago Cubs. Between games, Heathcote was traded from St. Louis to Chicago and thus played the morning game for the Cardinals and the afternoon game for the Cubs. (Courtesy Daniel J. Mays.)

Shown in civvies in the picture on the left, Glen Rock–born Clifton Heathcote (left) and St. Louis–born Charlie Grimm began as teammates in 1918 with the St. Louis Cardinals and remained close friends throughout their baseball careers. Below, Heathcote and Grimm are shown together in 1932. Heathcote was traded to Philadelphia later that year. It was his last year in the majors. In 15 seasons, Heathcote batted .275, with 42 home runs and 191 stolen bases. He died of a pulmonary embolism in 1939 at age 40. Grimm went on to manage the Chicago Cubs and the Boston and Milwaukee Braves. He died in 1983 at age 85. (Courtesy Daniel J. Mays.)

The 1948 Glen Rock baseball team, Southern York County League finalists, is pictured here. From left to right are (first row) Pete Stine, Gene Lukenbaugh, Roman Stiffler, Millard Krebs, Barto Sweitzer Jr. (mascot and batboy), Donald May, Clark Meckley, and Sam Kapp; (second row) Leo Bollinger (scorekeeper), Carroll Decker, Robert McCullough, Barto Sweitzer Sr. (manager), James Hoover, Harry "Hap" Trout, Robert Allison, Joseph Bierly Sr., Paul Bailey, Eugene Allison, and Ellsworth Rudisill (business manager). (Courtesy Daniel J. Mays.)

Shown here is the 1951 Glen Rock baseball team, Southern York County League. Pictured from left to right are (first row) D. Wagner (batboy); (second row) L. Firestone, R. Stiffler, G. Lukenbaugh, J. Bierly Sr., J. Mays (manager), S. Adams, R. McCullough, M. Herr, and F. Flickenger; (third row) G. Mergenthaler, J. Bierly, K. Allison, E. Allison, P. Bailey, C. Decker, G. Lukenbaugh, D. Werner, and K. Day. (Courtesy Daniel J. Mays.)

The championship 1952 Glen Rock baseball team, Southern York County League, poses for this group photograph. From left to right are (first row) Robert Allison, Carson Petry, Barry Black (mascot and batboy), Martin Herr, and Dale Smyser; (second row) Kenneth Allison, George Lukenbaugh, Robert McCullough, Eugene Allison, Paul Bailey, and Sam Nace; (third row) Paul Wildasin (groundskeeper), Donald Day, Sam Adams (manager), Joseph Bierly Jr., B. Kopp, Claudis Bortner, and William Krout (business manager). (Courtesy Daniel J. Mays.)

The championship 1954 Glen Rock baseball team, Southern York County League, is pictured here. From left to right are (first row) Barry Black (batboy); (second row) Otto Lehman, Lamar Warner, Carson Petry, Harold Masenhimer, Barto Sweitzer Jr., Mickey Ilgenfritz, and Jesse Mays; (third row) Almond Shaffer, Jack Keller, Donald Day, Tom Kerrigan, Carroll Decker (manager), James Hoover, and William Hickey. (Courtesy Daniel J. Mays.)

Pictured here is the 1957 American Legion baseball team. From left to right are (first row) Kenneth Roser; (second row) Ralph Cox, Neil Harvey, Richard Wagner, Charles Ecker, Gary Snyder, Charles Shearer, and Charles Godfrey; (third row) Nevin Grove (manager), Kenneth James, Lamar Rohrbach, Kent Sprenkle, Glenn Brenneman, Glenn Klinedinst, Earl Thoman (business manager), and A. Lamar Warner (scorekeeper). (Courtesy Daniel J. Mays.)

The 1958 American Legion baseball team is seen here. They are, from left to right, (first row) Charles Godfrey, Smith, Richard Wagner, and Kenneth Roser (batboy); (second row) Earl Thoman (business manager), Kent Sprenkle, Gary Snyder, Reno, Trout, and Charles Shearer; (third row) Kiick, Glenn Klinedinst, Bollinger, Joe Bierly Sr. (coach), Ralph Cox, and Nevin Grove (manager). (Courtesy Daniel J. Mays.)

The 1982 Glen Rock baseball team, Susquehanna League playoff champions, is pictured here. From left to right are (first row) Kevin Stiffler (batboy); (second row) Larry Stiffler (manager), Dave Thrift, John Devilbliss, Bill Demora, Charles Artz, and Floyd Bubb; (third row) Cindy Erisman (scorekeeper), Dave Stiffler, Allan Wagner, Jan Keeney, Terry Jones, Bruce Frick, and Dave Fitzpatrick; (fourth row) Greg Chambers, Perry Sweitzer, Rob Rinehart, Steve Walker, Kevin Jacoby, Kim McCullough, and Neil Klinedinst. Note that Rinehart and Fitzpatrick were former professional minor-league players. (Courtesy Daniel J. Mays.)

This 1937 photograph of Daniel Jesse Mays appears to catch him dreaming of the day that he will be a big-league ball player. Eleven years later after college and a stint in the army during World War II, Mays realized that dream when he signed a contract with the Pittsburgh Pirates organization. (Courtesy Daniel J. Mays.)

Daniel Jesse Mays played minor-league ball for the Pittsburgh Pirates in Greenville, Alabama, in 1948 and in New Iberia, Louisiana, in 1949. He was sold to the Boston Braves organization in 1950 and assigned to their Hagerstown, Maryland, team. Mays retired from professional baseball in 1950 and moved back to Pennsylvania. He is the author of the book *100th Anniversary of Sports in Glen Rock, PA 1894–1994*. (Courtesy Daniel J. Mays.)

Also popular and heavily supported in Glen Rock was the sport of basketball. This is the 1925 famous Radio Club town basketball team. Pictured from left to right are (first row) Roye Slonaker, Ken Keller, and Mervin "Pat" Stermer; (second row) Bud Seltzer, Chin Thompson, Diehl Keller, and Ponzi Royer. (Courtesy Daniel J. Mays.)

Pictured here is the 1930–1931 Glen Rock High School girls' basketball team. From left to right are (first row) Lucille Feree, Beatrice Sheffer, Dorothy Kapp, Amelia Lentz (captain), Anna Sterner, and Louise Snyder; (second row) Lurene Henry (business manager), Helen Unger, Mary Schwartz, Ethel Gladfelter, Ruby Roseberry, and coach Leander Hoke. (Courtesy Daniel J. Mays.)

The 1930–1931 Glen Rock High School boys' basketball team poses for this group photograph. From left to right are (first row) Emerald Smith, Grover Kirchner, Frank Hedrick (captain), Francis Bailey, and Lowell Rohrbach; (second row) John Kashner (business manager), Woodrow Miller, Russell McMillan, Clyde Bortner, Henry Kapp, Charles Seitz, and coach Leander Hoke. (Courtesy Daniel J. Mays.)

Pictured here is the championship 1931–1932 Glen Rock High School basketball team. From left to right are (first row) Park Rohrbaugh (business manager), Preston Hildebrand, Millard Slonaker, Lyman Moody, and Bruce Smith (scorekeeper); (second row) Raymond Stermer, Kenneth Keller, Albert "Buck" Elliott Sr. (coach), Auburn Bortner, and Barto Sweitzer Sr. (Courtesy Daniel J. Mays.)

The 1936–1937 Glen Rock High School varsity basketball team poses for this group photograph. From left to right are (first row) Leroy Krebs, Reed Allison, Nevin Grove, Albert "Buck" Elliott Jr. (captain), Courtland Shafer, Merle Williams, and Maynard Messersmith; (second row) H. R. Mutch (faculty advisor), Harry Geiman, Albert "Buck" Elliott Sr. (coach), Harry "Hap" Trout, Fuhrman Grove, and Arthur Hufnagel (manager). This team won the 1936–1937 York County Basketball Championship. (Courtesy Daniel J. Mays.)

Shown here is the 1937–1938 Glen Rock High School varsity basketball team. From left to right are (first row) Harry "Hap" Trout, Leroy Krebs, Nevin Grove (captain), Fuhrman Grove, and Maynard Messersmith; (second row) H. R. Mutch (coach), Millard Krebs, Eugene Rohrbaugh, Harry Geiman, Neville Seitz, and Mervin Williams (manager). (Courtesy Daniel J. Mays.)

Pictured here is the championship 1937–1938 York City League basketball team. From left to right are (first row) Carroll "Whitey" Heathcote, Henry Kapp, Barto Sweitzer (captain), Henry Mickey, and Harry Plymire; (second row) Bonnice Hare (York newspaper reporter), Johnny Betrone, Courtland Shaffer, Auburn Bortner (coach), Bud Stokes, Clair Trout, and Leo Bollinger (business manager). (Courtesy Daniel J. Mays.)

The 1940–1941 Glen Rock High School basketball team is pictured here. From left to right are (first row) Fred Flickinger, Richard Henry, Gordon Mergenthaler, Eugene Allison, and Robert Seitz; (second row) Horace Miller, Murrel Bollinger, Harry Leipold, John Lackey, Alvin Krebs Jr., and Paul Gaeckler (coach). This team won the 1940–1941 York County Division 1 Championship. (Courtesy Daniel J. Mays.)

The 1941–1942 Glen Rock High School basketball team poses for this group photograph. From left to right are Rene Williams, Robert Seitz, Atley Lehman, Gordon Mergenthaler, Eugene Allison, Murrel Bollinger, Richard Henry, Richard McWilliams, Robert Williams, Henry Stover, Paul Gaeckler (coach), and Roger Smith. (Courtesy Daniel J. Mays.)

Pictured here is the 1950 Glen Rock High School girls' track team. From left to right are (first row) Louise Bixler, Virginia Fry, Shirley Miller, and Charmaine Smith; (second row) Paul Gaeckler (coach), Lila Winters, Mary Bierly, and Marian Hendrix. In 1994, Bierly won the women's golf championship at Honey Run Country Club. (Courtesy Daniel J. Mays.)

Four

LIFE IN THE SURROUNDING AREA

This is Emily Abel and Margaret Grove Stover about 1900 during a country ride near the Foust Distillery north of Glen Rock. Abel's parents, Ben and Grace, owned and operated the Fountain Hotel on the corner of Main Street and Hanover Street in Glen Rock. The horse, Beryl, is pulling Abel's Bermuda carriage. (Courtesy Arlene O. Keller.)

William Foust built this distillery in 1858 in a valley north of Glen Rock. It produced Springfield Copper Distilled Pure Rye Whiskey that became nationally known. The popularity of the whiskey from this distillery resulted in a small community called Foustown, which grew around the distillery. (Courtesy Steven C. Grove.)

Foust's Distillery
Glen Rock, Pa.

Looking north from a hilltop at the Foust Distillery, one can see that the buildings are neat and well maintained. One of several of the warehouses at the plant can be seen in the foreground. Note the abundance of corn being grown close to the facility. (Courtesy Steven C. Grove.)

Warehouse A was one of several bonded warehouses at the distillery. This one reached six stories. Prohibition caused the distillery's downfall. However, today the distillery has a cultlike following. Items marked with the Foust Distillery name are highly sought after. This has resulted in many reproductions and fakes appearing on the market. (Courtesy Steven C. Grove.)

This 1912 photograph was taken not long after automobiles began appearing regularly on area roads. Foust's Warehouse A is the large structure looming the background. Note the old metal mailbox attached to the post next to the tree. (Courtesy Steven C. Grove.)

This Foust smokestack can clearly be seen along Glen Rock Road (Pennsylvania Route 216), and it marks the location where the Foust Distillery once stood. This is not the original stack seen in the older photographs. This stack was built when it was planned to produce industrial alcohol at the plant during World War II. That never materialized, and this stack was never used. Below are some of the remains of the distillery. (Author's collection.)

Geiple's Furniture Store was in the building that still stands on the site of the Cold Spring Hotel (later Hotel Glen). Geiple's Funeral Home is in the right side of the building, and the furniture store was in the left side. This chair was an advertising piece for the store. It is painted bright red with yellow lettering. It was not unusual years ago for a town's local undertaker to have a furniture or woodworking business. When not making caskets, he manufactured or sold furniture. Geiple's Furniture Store opened in 1928 at the hotel property and closed in 1993. (Courtesy Bob Keller.)

This is Enterprise Furniture Company, headed by George W. Geiple, in the former Cosmo carriage factory. At one time, the Enterprise Furniture facility consisted of five major buildings. Nearly all are gone now. The upper floors of this building were removed, and the spaces were heavily renovated to accommodate private business space and apartments. (Courtesy Steven C. Grove.)

Roll of Honor

A DIRECTORY OF CASUALTIES
(DEATHS ONLY)
OF THE
GREAT WAR OF DEMOCRACY
1914–1918
OF
YORK COUNTY

Dedicated to Perpetuate Those Who Made the Supreme Test

"THEY SHALL NOT BE FORGOTTEN"

NAMES

SEVEN VALLEYS
Private Clayton D. Warner
Private Chas. W. Bine

GLEN ROCK
Private Austin L. Grove
Private Quenton M. Gerbrick

STEWARTSTOWN
Corporal Alvin Rehmeyer

NEW FREEDOM
Seaman Millard Kearney
Private Frank Shauk, Jr.

SHEWSBURY

SEITZLAND
Ensign Robert N. Weaver

LOGANVILLE
Private Howard L. Goodling

LAUREL
Private John Uhes

DOVER
Private Granville Smith
Private Harry Kinsey
Private Chas. Witmer

DELTA
Corporal John M. Wise
Private John A. McKee
Private Chas. Heaps

GATCHELVILLE
Private Aug. U. Strawbridge
Private Chester H. Bais

MUDDY CREEK FORKS
Private Chas. R. Burkholder

HOPEWELL
Hosp. Apr. Valentine K. Lutz

BRYANSVILLE
Private John M. Wise

FELTON
Private Geo. H. Sechrist

PEACH BOTTOM
Private John T. Faws

This roll of honor lists the names of 23 residents of York County who lost their lives in World War I, shown here as the Great War of Democracy, 1914–1918. The two names listed for Glen Rock are Pvt. Austin L. Grove and Pvt. Quenton M. Gerbrick. This roll of honor hangs in the Austin L. Grove American Legion Post that was named in his honor. (Courtesy American Legion Post 403.)

People gather on Manchester Street for the dedication of the roll of honor for the Glen Rock–area citizens who served during World War II. The roll stood in front of Trinity United Church of Christ (Trinity Reformed Church). The church stands on the left. The house on the right has been removed and is now a parking lot for the church. (Courtesy American Legion Post 403.)

This is Harry H. Foust in uniform during his service in the army in World War I. Foust served in the infantry with the American Expeditionary Force (AEF) and saw action in France, including in the bitterly fought Meuse-Argonne campaign. He served 19 months and achieved the rank of first sergeant. (Courtesy Bob Keller.)

The Foust family is pictured in Glen Rock in the 1950s. From left to right are Harry H. Foust, Phoebe Foust, Florence Keller, Margaret Heathcote Foust, and Robert Foust Keller. The boys in front are Robert and William Keller, sons of Robert Foust Keller. Margaret Heathcote Foust was a direct descendent of William Heathcote, founder of Glen Rock. (Courtesy Bob Keller.)

This aerial photograph of Wetzel's Market on Manchester Street was taken when it was known as Smith's Market. Note that when this 1970s photograph was taken, the entrance to the store was on Manchester Street. Smith's Market became Wetzel's Market in April 1985. (Courtesy Wetzel's Market.)

This 1907 postcard view of Argyle Street shows how susceptible the area is to flooding. Heavy rains or a fast spring thaw would most likely cause the South Branch of Codorus Creek to rise beyond the small embankment. This area, like other parts of Glen Rock, received significant damage in 1972 from the floodwaters of Tropical Storm Agnes. (Courtesy Steven C. Grove.)

This is Seitzland, located about a mile south of Glen Rock. Many of the buildings shown in these early-1900 photographs are still standing and in use today. The small lake that was formed by a dam on the South Branch of Codorus Creek no longer exists. At the time of these photographs, it was a popular swimming and ice-skating place. (Above, courtesy Steven C. Grove; below, courtesy Kerry and Deb McKnight.)

This is the Seitzland Hotel. Little is known about the structure, except that it still stands in Seitzland and is now painted red. Judging from the clothing, this photograph is probably from the late 1800s or early 1900s. (Courtesy Ed Hughes.)

Besser's Department Store and Tourist Camp was a popular stopping place along the Susquehanna Trail (U.S. Route 111). After the newer U.S. Route 111 (now Interstate 83) was constructed, most traffic was diverted away from this location, and business declined. The first to go were the small cabins that were located behind the main building. Note the farmer at right plowing the field with horses. (Courtesy Frank Ingham.)

BESSER'S DEPT. STORE & TOURIST CAMP
MI. SO. OF YORK, PA. — 38 MI. NO. BALTIMORE, MD.

Besser's main building was eventually razed, and the new Shrewsbury township building sits at this location. To the right of Besser's was once a drive-in theater where the veterinary clinic now stands on Theater Road. (Courtesy Bob Keller.)

This is an old stone mile marker that stands along the Susquehanna Trail (old U.S. Route 111) near Glen Rock. Several of these markers are still in place along the road; however, this is one of the few that can still be barely read. This marker indicates that the location is 36 miles from Harrisburg. (Author's collection.)

This is Rocky Ridge Motel as it appeared in 1969 off the Glen Rock exit of Interstate 83. The motel advertised that it offered 18 modern units with a scenic view, wall-to-wall carpet, tile bath, television, and air conditioning. The motel was owned and operated by Ruby and Allen Myers. Note the aluminum-and-glass-style telephone booth on the left corner of the building. (Author's collection.)

This postcard view looks out Baltimore Street toward the area of the old Heathcote mill long before the Steiner-Liberty factory was built. Glen Rock Light and Power Company, Edison Light and Power Company, and, later, Metropolitan-Edison operated a substation between the creek and Baltimore Street. The sewing factory on the left side of Baltimore Street burned down on October 19, 1916. (Courtesy Steven C. Grove.)

This view was taken looking out Baltimore Street toward where the old Heathcote mill stood. Water was dammed at this point and the millrace for the mill, now the Glen Rock Mill Inn, began here. Valley Street is the road that crosses the railroad tracks. Notice the assortment of utility poles that line both the railroad tracks and Baltimore Street. (Courtesy Keller-Brown Insurance Services.)

The long, tall redbrick apartment building that stands along Baltimore Street was once the Steiner-Liberty sewing factory. Steiner-Liberty Corporation manufactured garments, including pajamas, and operated sewing factories in Glen Rock and Shrewsbury. In earlier days, the company name was painted in black and white on the facade of the building. (Author's collection.)

The building on the corner of Main Street and Baltimore Street at one time or another contained about every type of business conceivable. Built in 1870 for furniture manufacturing and sales, it later held buggy sales, a meat market, a variety store, a grocery store, a restaurant, a post office, a shoe shine parlor, a telephone exchange, and numerous apartments. At the time of this picture, it was the Glen Rock Variety Store. It was heavily damaged by fire on March 18, 1999, and later razed. (Courtesy Glen Rock Mill Inn.)

This is the former telephone exchange building at Centerville. The building was constructed by York Telephone Company to replace the telephone exchange on Manchester Street that was razed to make room for an addition onto the bank at the square. (Author's collection.)

It is not known what is occurring in this photograph, but it was urgent enough to cause two passenger trains to be backed up on the north side of the Water Street crossing. Workmen can be seen digging between the sets of tracks and also between the rails of the center set of tracks. An advertisement similar to the one seen on the side of Israel Glatfelter's store (at right) is still visible today. The entrance to the Glen Rock Mill Inn is just beyond the railroad crossing gate on the right. (Courtesy Ed Hughes.)

NORTHERN CENTRAL RAILWAY

SPECIAL SCHEDULE

FOR

The President's Funeral Train,

For Friday, April 21, 1865, and to remain in force for that day only.

☞ This Train has the right of Road against all Passenger, Freight and other Trains.

All Passenger, Freight and other Trains must keep entirely out of the way of this Schedule, as provided in special orders printed below.

Baltimore,	Leave 3.00 P. M.
Bolton,	" 3.06 "
(End of Double Track,)	
Relay,	" 3.11 "
Timonium,	" 3.27 "
Cockeysville, (End of Double Track)	" 3.44 "
Sparks',	" 3.56 "
Monkton,	" 4.14 "
Parkton,	" 4.27 "
Freeland's,	" 4.50 "
Summit No. 1.	" 5.10 "
	Arr. 5.20 "
	Leave 5.25 "
Glenrock,	" 5.42 "
(End of Double Track,)	" 5.45 "
Hanover Junction,	" 5.55 "
Glatfelter's,	" 6.03 "
York,	Arr. 6.30 "
	Leave 6.35 "
Summit No. 2,	" 6.53 "
Conewago,	" 7.05 "
Goldsboro',	" 7.21 "
Red Bank,	" 7.39 "
Bridgeport,	" 7.55 "
Harrisburg,	" 8.10 "

FAST FREIGHT SOUTH failing to make Cockeysville, (end of Double Track,) on time, will keep ONE HOUR off of time of Special Schedule, and remain on Siding until the Special Train passes.

MAIL TRAIN SOUTH arriving at Parkton on time, will remain there until Special Train passes. Failing to make Parkton on time, it will keep 40 minutes off of the time of Special Schedule and remain on Siding until Special Train passes.

LOCAL FREIGHT, NORTH AND SOUTH—York and Baltimore—are annulled for this day.

LOCAL FREIGHT SOUTH, AND COAL TRAINS SOUTH will not pass Cumberland Valley Rail Road Crossing at Bridgeport, until the Special Train arrives and passes on to the Cumberland Valley Bridge.

ALL GRAVEL AND CONSTRUCTION TRAINS will lay off and will not occupy Main Track between Bridgeport and Baltimore after 12 mid-day of Friday until Special Train passes.

PARKTON ACCOMMODATION, SOUTH, will not leave Parkton until Special Train passes.

☞ A PILOT ENGINE will run on the time as printed on this Schedule, carrying Flags for Special Funeral Train, which will follow ten (10) minutes after the Pilot Engine.

J. N. DUBARRY, Gen'l Supt.

Office Northern Central Railway, Baltimore, April 21, 1865.

This is the funeral train notice issued by the Northern Central Railway directing all of its trains to stay clear of the one carrying the body of assassinated president Abraham Lincoln on April 21, 1865. The locations and times shown on the notice were for the pilot engine that preceded the "Special Funeral Train" by 10 minutes. The notice shows that the pilot engine was to pass through Glen Rock at 5:42 p.m. (Courtesy Glen Rock Mill Inn.)

This 1940 aerial view shows the area of Church Street, Center Street, and Park Avenue to be sparsely populated by today's standard. The corner of Church Street and Center Street (near the left edge) is where the Glen Rock Post Office stands today. Heyward Heights was still mostly wooded when this photograph was taken. (Courtesy Sally Zimmerer.)

Harry and Emma Geiple built the house at the top of this picture in Heyward Heights in 1912. Harry Geiple put in these concrete steps from Main Street to Heyward Heights about 1914. There was also a set of steel-frame steps at this location. Both sets of steps were used until the steel steps were removed in the early 1950s. The Glen Rock sign on the right is a Pennsylvania Railroad–style sign that stands along the Heritage Rail Trail. (Author's collection.)

Here is the underpass that carries the Heritage Rail Trail over Pennsylvania Route 616 and the South Branch of Codorus Creek. There are two such structures on Pennsylvania Route 616 between Glen Rock and Railroad. The railroad built these culverts in such a manner so that separate ones were not needed for the roadway and the creek. (Author's collection.)

This is a small cardboard puzzle advertisement for the Glen Rock Garage on Hanover Street at the time Harry H. Foust and Fuhrman Hershner operated the garage. Robert Foust Keller operated the garage later, and he converted it into a bowling alley. The structure sat two doors beyond the fire hall at 21 Hanover Street. (Courtesy Bob Keller.)

White Oil Rubbing Liniment is pictured here. The box says, "No Family Medicine Chest complete without this valuable household liniment." The bottom of the bottle label says, "Prepared for Glen Rock Cut Rate Store, Glen Rock, PA." The Glen Rock Cut Rate Store, operated by Park Rohrbaugh, was in the old Fountain Hotel at 2 Main Street. (Courtesy Bob Keller.)

Emily Abel stands in front of the post office at the corner of Baltimore Street and Manchester Street. Through the years, the post office has been in at least seven other locations on Main Street, including numbers 3, 16, 31, 39, 43, 47, and 50. Its present location is on the corner of Church Street and East Center Street. (Courtesy Arlene O. Keller.)

On July 1, 1921, a fire started in the Read Machinery Company and quickly spread to the J. F. and H. O. Neuhaus hardware building at 32 Main Street. Glen Rock Fire Company did not have modern firefighting equipment, and the fire was soon out of control. Firefighters spent most of their time protecting nearby buildings while constantly in peril from exploding fireworks and dynamite in the hardware store. More modern firefighting equipment had to be sent by rail from York to assist in battling the blaze. (Courtesy Kerry and Deb McKnight.)

HANOVER ST. GLEN ROCK PA

Here are two postcard views of Hanover Street. The top postcard shows Hanover Street in 1910. The street has not yet been paved, but sidewalks have been installed. There was little automobile traffic at that time, so the utility poles in the street posed little danger, and they also provided a convenient place to tie a horse and buggy. The bottom postcard shows the street in 1916 at a different location. It is still unpaved. The steepness of the hill may have been a challenge to that early-style automobile. Note the hitching posts on each side of the street. (Courtesy Steven C. Grove.)

Hanover Street, Glen Rock, Pa.

This undated postcard view of Hanover Street is quite interesting. One can only wonder why the street is in such a terrible condition. This could have been damage from heavy rains and water coming down the hill. Nonetheless, it certainly had to result in a slow, bumpy ride in that buggy parked on the side of the street. (Courtesy Steven C. Grove.)

This is a card table manufactured by the M. Ware on Wissahickon Avenue in Philadelphia. Ware made and sold this style table for a variety of reasons, including local fund-raising. Advertising space on the table was sold to businesses. The cost of the advertisement was dependent on the size of the space. In certain cases, the space is marked, "Compliments of a Friend." (Author's collection.)

Several of the companies shown on the table are no longer in business, and in many cases, the buildings no longer exist. This particular table was made of fiberboard with hardwood legs and trim. The color of the table is maroon. Card tables were very popular in the 1950s and 1960s, when friends would gather to play cards for entertainment and to socialize. Few of the Glen Rock tables exist today. (Author's collection.)

These are two hand-decorated postcards from 1907. Postcard salesmen made this style card with glue and sparkles and included the name of the town in which he was doing business. Several of the images in this book are from old postcards. In its day, it was a quick and fairly reliable means of communication. Several of the postcards used in this book had simple messages informing someone that the sender had arrived in Glen Rock safe and sound after a train trip from York, Harrisburg, or Baltimore. Today one would be hard pressed to find a current-day postcard in any small town. (Courtesy Steven C. Grove.)

This style sign was once erected by the state near the borough line on each of the major routes coming into town. This sign indicates that Glen Rock is 10 miles from York, that it was originally called Rocks in Glen, and that it was founded in 1838. Rocks in Glen is only one version of how the town is believed to have gotten its name. The borough is fortunate to have this on display at the library, as few of this style sign still exist statewide. (Author's collection.)

Across America, People are Discovering Something Wonderful. Their Heritage.

Arcadia Publishing is the leading local history publisher in the United States. With more than 3,000 titles in print and hundreds of new titles released every year, Arcadia has extensive specialized experience chronicling the history of communities and celebrating America's hidden stories, bringing to life the people, places, and events from the past. To discover the history of other communities across the nation, please visit:

www.arcadiapublishing.com

Customized search tools allow you to find regional history books about the town where you grew up, the cities where your friends and family live, the town where your parents met, or even that retirement spot you've been dreaming about.